A Box of Depends
and a
Bottle of Tequila

MISTI GALVES

SHERI MALVESTUTO

ISBN 978-1-64028-702-0 (Paperback)
ISBN 978-1-64028-704-4 (Hard Cover)
ISBN 978-1-64028-703-7 (Digital)

Christian Faith Publishing, Inc.
296 Chestnut Street
Meadville, PA 16335
www.christianfaithpublishing.com

Printed in the United States of America

Chapter One

I quickly walked through the aisles of CVS, glancing at items on the shelves, not really seeing them but making the effort anyhow. Turning my head from side to side, as if somehow the effort would give me a feeling of normalcy, I looked but didn't really see the items around me. My mind was focused on one thing only—the list! The wave of emotions crashing through my head, beating themselves against my conscience thoughts, was more than I wanted to deal with right now. I had to escape and just keep going so that I wouldn't break down. Through sheer willpower and the support of my family, I had continued on all these months and years with no clear understanding of why or how. All I knew was that I must; failure was not an option! There was no other choice that I could have made that I would have felt comfortable with. My choice had been clear from the start, but convincing others of that was another story. I had to continue on this journey no matter what. The die was cast, the decision was made, and now all that remained was to buckle up and enjoy the ride as I delved deeper into this crazy world that had become my life.

I stopped in front of the pharmacy, quickly taking stock in my head in case I had forgotten to write something down. I glanced at my list, but it was always the same; it never changed. No matter how many times I wrote it, it always had

the same two items listed. I didn't have to look, I knew what was there. Hell, I had it memorized by now! I kept going past the pharmacy and into the nearby aisle. *Ahh, here we go!* I grabbed the green box and moved on to the next item. It was one of those beautiful summer weekends in sunny San Diego when everyone was headed to the beach for fun in the sand and surf with their loved ones. But not for me; I had made a mad dash into the shower around ten o'clock and headed out to get more supplies, making sure that my mother was all right with Bob before grabbing my keys and the list. And now here I was running mad dash style through the aisles, wet hair flying behind me, mascara threatening to run down my face through the tears I was feebly trying to blink back.

I looked through the cases on my right, searching high and low, but I didn't see what I was looking for. *No,* I screamed in my head, *they can't be out! I need it!* Now the tears were flowing, and I couldn't help it. I needed that bottle like I needed air right now. They couldn't be out, not when my very sanity depended on me having the contents of that bottle. A few more seconds of tears and rearranging the bottles on the shelf and then, "Ahh! Here it is! My savior in a bottle, it was right in front of me the whole time!" I wiped my eyes on the sleeve of my shirt and took my purchases to the counter, where there was some old lady with a basketful of junk and about a thousand coupons! I tried to patiently wait my turn, but I wondered how Bob was doing and if those crazy monitors were going off like belles. Then I thought of my mom and wondered if she had the strength to do what only I could do if they did start to ring like crazy.

No! Stop it, Sheri, I scolded myself. *You can't think like that, everything's fine. I've left him with other countless times, and he's always been fine, why should today be any different? Why?* I thought to myself. Why not? This whole thing wasn't fair. We should never be going through this. Bob was my

4

rock, the one I depended on, but now he was sick, and I had to be the strong one. I had to work to make a living. I had to be the one to start up a new organization on a whim and not only devote myself to making that work but also be with Bob, who needed me so much right now. I needed to be strong for him and push my own needs and desires to the back burner, but it was hard to do. So many times I wanted to remember what it was like to be a woman again. I just wanted to have someone hold me the way Bob always held me and make love to me the way Bob made love to me. No, not just someone; what I really wanted was Bob back, to be that woman in love needing him to shower affection on and feel his love and appreciation in return. Was that really too much to ask? But those days seemed far away now, and my friends kept telling me, "Sheri, we can get someone for you. You don't have to live like this. It's like going to the spa and getting a pedicure, but that's something I could never do, not as long as I had Bob. At least, some part of him was still there, and I would never give up hope! I longed for him to open his eyes and look at me the way he used to and say, "Everything's going to be all right, Peety. You're doing great!" I pushed my fears to the back of my mind and concentrated on the present, brushing away a few more tears.

I glanced to my left as a man about six feet tall stood next to me in line with a bag of Frito Lay corn chips, two cans of bean dip, and a six-pack of Coronas in his hands. He smiled at me, and I smiled back, trying to keep from staring at his enormous gut the size of a basketball. *Maybe he should lay off the beer and bean dip*, I thought to myself. Finally, the checker, a tall, middle-aged woman with black hair tied loosely in a complex-looking braid with half her hair sticking out at odd ends and the rest falling out of it, began to move the items off the belt and make room for the rest of us. She had piercing green eyes and a worn-out red apron, but she

moved with speed while I grabbed one of those dividers and put my items down on the belt…a box of Depends and a bottle of tequila!

The man behind me did the same and looked over at my items and back to me. The checker began to bag the old lady's groceries now. The old lady smiled warmly at me and glanced from my tear-stained face to my Depends and bottle of tequila, and her smile faded to a look of confusion. The checker glanced over and stopped mid-bag long enough to smile knowingly and nod her head at me as if she too understood and had been through the kind of year I had had. She seemed to divine my urgency and sped the old lady on her way out the door. I imagined what a sight I must be making—standing here with wet hair, mascara running down my face, and my box of Depends and tequila in front of me with that "after the day I've had, don't mess with me" look on my face. I paid the lady, mumbled a relieved thank-you, and hurried out to my car. As I exited the drugstore, I had to laugh, with all the training from Tony Robbins, my yoga, my self-help tapes, my Bible, and anything by Gary Zukav and Wayne Dyer; here was my life, right along with a little liquid courage and a box of Depends.

Chapter Two

I pulled into the driveway and rushed into the house. The TV was going—no sound, just pictures—while soundscapes soft music played in the background. I would always leave Bob this way—just music, no words. TV and regular music with words started making him too nervous. He couldn't track it; there was just too much confusion in it. It would always make me laugh because Bob was a blues guy. He played the drums and loved James Brown ("I Feel Good" was our wedding song), so the idea of him sitting still enough to listen to soundscapes would have made him looney tunes prior to this. It's crazy how life works out sometimes.

Mom was good, sitting by Bob's bed, rubbing his hand while she sang to him. The dogs, Moochie and Alfie, were curled up at her feet. I nodded and waved as I ran to the small table of our granny flat with the bag and carefully took out the bottle of tequila, setting it down gently. I unpacked the Depends and placed them on a shelf near the bed. Then I grabbed not a glass but a very large mug and the tequila bottle. I ran out the door across the breezeway into the kitchen that I shared in my parents' house. I grabbed a handful of ice and dropped it into my mug. The dogs came running, and I poured the tequila into it. I took the mug and slowly savored the sharp liquid as it ran down my throat.

Ahhh, I sighed, and every muscle in my body began to relax. A few more slugs on the tequila and I walked back to the flat and then over to the bed.

I bent down over Bob, my head close to his face. I brushed my hand across his forehead and over his smooth head. I began to sing in a soft and sultry tone. "Happy birthday to you. Happy birthday to you. Happy birthday, dear Bob. Happy Birthday to you." I kissed his lips gently, and he reached up to pat my head with a big sunshiny smile as if to say once again, "Good job, Peety." This was our little routine.

My mother, confused by this exchange, asked me, "Is it his birthday again?"

"No, Mom," I said, chugging down some more tequila. "I sing 'Happy Birthday' to Bob because it always makes him smile so bright and pat my head the way he used to. I just wanted to see him smile again."

My mom grabbed my hand and squeezed it gently, ignoring the tears that tried to well up again in my eyes, and said, "Well, I need to get back and check on your father. You going to be all right here?"

"Yeah, Ma, I'm going outside for a while and get some sunshine," I said, turning on the baby monitor beside Bob's bed.

My mother stood and headed for the door. "Okay, that's a good idea. If you need me again, give me a call."

"Thanks, Ma, I will." I drained the contents of the mug and checked one more time to make sure Bob had everything he needed. I washed the mug, patted the dogs, and then headed out the door.

On the weekends, I was always out on the one and a half acres weeding, cutting down limbs of trees, and always with my baby monitor strapped to my waist so that I would be a quick run to the room if I heard a strange sound coming from

Bob. Today was no exception. After a little liquid courage break, I was ready to tackle those vines creeping up the garage. This was therapy for me, and I didn't mind the work at all. It always got my mind centered and off the obsessing over my day-to-day routine and Bob's progressing Alzheimer's. I grabbed the clippers and began to clear away the vines, laughing at myself and wondering how on earth I got here!

Taking a moment to reflect, I gazed back over the years of my life that had brought me to this point. I wasn't always this out of control, always running a mile a minute to stay one step ahead of the fears and doubts that were constantly plaguing me with Bob's condition. In fact, I had led a pretty good life, I would say. I had grown up in California with my parents and met my husband, Steve Wetherbee. Steve was handsome, tall, had blond hair and blue eyes with black-rimmed glasses. He had the look of a total surfer dude with his tan skin and firm chiseled body. He was on the varsity football team, played the twelve-string guitar, and loved to write poetry. Steve was not the typical aggressive, macho, jerk you encounter in football players. Instead, he was quiet, shy, non-emotional with a sweet and almost innocent demeanor, and I was smitten with him. He was my best friend and my first boyfriend, and we were so cute together. I wore his Saint Christopher's medal proudly over my sweater every day to school and cheered the loudest at his games. My Steve and I were everyone's idea of your typical first love, puppy dog crush, high school sweethearts—whatever you want to call it, we had it. It was one hell of a great relationship. We would walk down the hallways holding hands and being kissy-faced everywhere we went. He wasn't an overly emotional guy, and other than the usual kiss and holding hands, nothing beyond that ever occurred. Steve was every bit a gentleman and was always respectful of a girl's honor. It didn't matter we had a great friendship, and I could tell him anything and vice versa.

Steve was the athletic type, and he loved to help people. He always wanted to be a paramedic. He had such great plans for us after high school, and at the time, they sounded like every girl's dream of a happily ever after. However, Steve's parents were not as supportive of his desire to be a paramedic as Steve had hoped. His dad had argued against it when he was told and tried to push Steve into being an IBM pencil pusher at some corporate office for the rest of his life, but Steve merely shrugged it off and continued with his plan. We were so young and happy and on our way to our senior prom. Steve hated to dance and refused many times, but we were going anyway just to see our friends off and have one last big bash before everyone left to start the rest of their lives.

We were just nineteen, both still virgins, when he convinced me to marry him. It was a decision I had weighed very carefully. I liked him, and he was a very good friend of mine, but I wasn't crazy in love with him or anything like that. I loved to be around him, and it might be kind of fun to be married to him and have a family together, but hot and passionate feelings just didn't exist between us. I talked to my mother about it and asked her if this was normal. I felt like I should be having passionate can't wait to get near him feelings like they portray in the movies, but I had never been in love before, and this was new territory for me. She assured me that this was normal and that all women felt like this. So with an admonition like that, how could I resist? This was what love should be after all, my mother had said.

Steve enlisted in the army to follow his dream of being a paramedic, and we moved to be close to his work. We lived in a little apartment in an area of San Francisco called the Tenderloin District, unknown to us at the time as having gotten its name from the multiplicity of hookers who "worked" in this area. Steve worked at the Presidio, while I made minimum wage at the Bank of America on Geary

Street. Ah, those were good times; life seemed to be what it should be for two people just starting out in life. Steve was a crack-up, and I would laugh at his prudish nature when I would dress up in sexy lingerie, which seemed to make him uncomfortable. One day, I got this erotic idea of dressing up for him when he got home from work, so I took a nice hot bath with beautiful smelling salts that made my skin like silk. I put on my sexiest little black lace nightie, the one with the peek-a-boo panties and see-through nipples, and then threw on a matching cover and waited in the dark living room. When Steve came home from work that night, he turned on the light in the kitchen and looked around for his dinner.

I walked out from the living room, and in a sexy sultry voice, I said, "Hey, hot stuff, why don't you have some of this?" I opened the cover so he could see the sexy outfit underneath.

Steve jumped in surprise, yelling, "Geez, Sheri, what are you wearing?"

"It's my nightie," I said confidently, running my hands down my hips. "Don't you like it? I picked it out just for you."

"It looks like underwear. That's not a proper nightgown. Go put some clothes on."

Needless to say, I was disappointed with the response, and the following week, he came home with a package under his arm.

"Here, I got you a present." He proudly set it down on my lap.

I tore through the ribbon and paper and then carefully opened the box. I lifted out a brown flannel floor-length nightgown with long sleeves, decorated with lace around the cuffs and neckline. It was the ugliest gift I had ever been given. Steve sat next to me, smiling brightly as if he had just given me the Hope Diamond.

"There, now you have a proper nightgown," he said, patting my hand.

I cried. It was clear to me at this point that Steve wanted the 1950s American dream wife. He was expecting me to be the sweet little wife who stays at home taking care of the kids cleaning the house and fixing dinner, never talking about sex or being overtly sexual, just acting like the innocent girl who had no idea what sex was, or even letting on that she liked it. This was definitely not me. I was a beautiful, confident woman, and I liked sex and my body. I was a happily married woman and wanted to explore my sexuality with my life's partner and best friend. This should be what married people do, but Steve was having none of it. Things would have to change before we both became unhappy. Steve would either have to expand his sexual horizon with me or deal with my sexual confidence and pretend to like it.

During this trial and error period of our marriage, we got the call that every woman dreads. Steve had to ship out! I had always been aware that this was a possibility when he signed up but had hoped it would never come true. Here it was not even a year into our marriage, and he was going to Vietnam, shipping out the following day with the 24th Evacuation working as a medic during the day and ranger at night in Ben Hoa. It was a hard job for a nineteen-year-old—fixing up soldiers by day and crossing dangerous enemy lines at night to take out enemy troops. But this was our new reality, and I would sit up nights wondering if he was hurt or sick and praying to God that he was safe.

While Steve was away that year, I moved back with my parents in Visalia, California. My dad ran a Montgomery Ward catalog company while flying his Cessna, and Mom helped out there too. Luckily, I was able to transfer yet again to the Bank of America in Reedley. So there I was commuting every day and listening to Wolfman Jack on the

radio station just outside of Bakersfield when I got a call—Steve was coming home! The army transported a very weak and broken Steve back home; he was burned out and full of horrible stories and nightmares that haunted him. Steve and I remained with my parents for a while but he wasn't the same. I noticed a marked difference in his attitude now. He was always a quiet and calm man, but now he would sit in the dark for long periods of time and just tune out in the middle of conversations, not at all like he used to be.

He tried to find work, but in 1970, when people heard you were an out-of-work vet from Nam, no one would give you a second look. It was a very unpopular war, and anyone who had done a stint over there was labeled baby killers when they returned stateside. Because of politics and public opinion, Steve was unemployed, and not even odd jobs were open to him. It was hard on his ego to have to let me work to support us, but he couldn't even find a job in a grocery store unpacking boxes. So he thought a change of scenery would help, and we moved to the San Fernando Valley where I grew up as a kid in the hopes that he would have better luck there. Unfortunately, for Steve, things were the same—still no work. I, on the other hand, was supporting the two of us on my income from the National Security Bank. I had gotten a job running one of those big NCR machines, clearing checks and deposits through for the bank every day. Steve was starting to slip into depression, and his nightmares grew more violent.

Chapter Three

The sun was hot, and it beat down on me while I kept pulling at the tangle of vines around the garage. I stopped my reverie for a moment, wiping the sweat from my face with the back of my hand. It sure was a crazy journey. I thought back to that second year when Steve had come home; that was the beginning of the end for me. I finished my rest and turned back to the work at hand, musing again about that time in my life when things seemed simpler.

A year later, things were still the same. I was working the bank scene, and Steve was still out of work. We had started to drift into silence more and more. What he saw and did during the war placed a giant gulf between us that was impossible to cross. He wouldn't talk to me about it. He thought I wouldn't understand. Anybody who wasn't there would never get it, he used to say to me. But the horrible things that happened there were with him every day were making him act out in ways that were becoming more violent and dangerous. Realizing there was no other option for work at this time, Steve decided to re-up in the army, and he got a job in Denver, Colorado, working to re-acclimate POWs returning from Vietnam. Thinking this might be the best way to help Steve cope with his experience in the war, I was all for it. So I figured anything that would bring him back to reality and fix this situation was worth the move. I loved

Steve dearly, and I wanted to help make him better, but it was beyond my power to fix this, so I hoped and prayed the army would be the answer to his broken psyche since they were the ones who broke him in the first place.

Denver was beautiful. It was late winter when we moved, and the drive to our new place was a bit slow due to the fresh falling snow, but I loved it. We didn't have snow in California, and this was a rarity I intended to enjoy. As we drove along the small winding road, the white landscape looked so still and deserted. I hadn't seen a car in at least twenty minutes, and there were no houses at all along the road. It was so still and quiet I felt as though we were driving through a postcard. I just couldn't stand it any longer. I knew Steve was in a hurry to get home, but I just couldn't stay in that car anymore. I had to get out and experience this beautiful sight around me.

"Stop the car," I shouted giddily.

Steve looked at me, confused, and said, "What?"

"I said stop the car." I was rolling down the window.

"Stop, why? Sheri, are you sick," he asked, concerned.

"Just pull over," I shouted, sticking my head out the window.

The strong scent of pines stung my nostrils as I breathed in deeply the fresh piney mountain scent. I was in awe at the sight around me. Steve pulled the car over and stopped beside a wide open glen on the side of the mountain. The trees were thick along the fence leading into the forest, but the glen was open with a few scattered trees amidst the pure white, sparkling, freshly falling snow. I couldn't wait for him to come to a complete stop, and I dashed out of the car in the middle of the mountains. I stood for an instant, admiring the scene before me. It was deathly silent, and I could hear the wind rustling and swaying the branches of the trees back and forth above me. The fresh pine smell was clean and crisp,

and I squealed in delight, running down the hill to the glen, stripping my clothes off piece by piece, leaving a scattered trail of clothing behind me as I went.

Steve got out of the car and yelled over the hood, "Sheri, where are you going?"

I dove into a large pile of snow, laughing and gasping as the biting cold hit my naked body. "Come on, Steve, let's play in the snow. Look!" I said, lying on my back, screaming from the cold, as I spread my arms and legs back and forth across the snow. "A snow angel. Come and make one with me."

"Are you nuts?" asked Steve, standing beside the car, his wool jacket pulled up to his ears. "It's forty below. I'm not taking my clothes off here. Besides, someone will see you."

I grabbed a handful of snow and rubbed it through my hair as if I was washing it. "Don't be ridiculous. Who's going to see me? There's no one around for miles. Come on, Steve, please. Let's have some fun together."

"Come on, Sheri, I'm not kidding," he said, opening the car door. "Get back in the car before someone shows up and sees you like that." And he got back in the car and slammed the door behind him.

I tried to ignore his remark, but it was too late; the spell was broken, and I reluctantly got up and began collecting my clothes. I shook my head and rolled my eyes toward the car as I began to dress. Steve was a sweet man, but he just wasn't adventurous like me, and neither did he love my independent spirit. I could find beauty and adventure wherever I went, but Steve liked things to be proper and in their rightful place. While I was off exploring my freedom and expressing my emotions, he was busy hiding his and trying to suppress me from expressing mine. This was just another classic example of the differences in our outlooks on life and happiness. As I walked back to the car, a delightful thought popped into my head. I knew Steve wouldn't go for it, but I had to ask anyway.

I opened the car door and slid into the seat. Leaving the door open, I looked over at Steve with a mischievous grin. "Hey, Steve, I have a thrilling idea. Let's go out there and make love in the snow!" I said playfully, rubbing my hand along the inside of his thigh.

"What!" he asked, horrified and glaring at me over the black rims of his glasses. "Why on earth would you suggest that? It's cold out there. We could freeze to death."

"Oh, Steve, don't be silly." I pleaded. "It's not that cold, and we would be creating our own heat, babe, and it would be so nice and toasty between us there wouldn't be enough time to freeze to death," I added sarcastically.

"You want to have sex out there in the middle of the woods for the whole world to see!" Steve screamed, pointing his arm toward the glen. "I just don't get you, Sheri. That's something we do in private, not as an exhibition for the whole world!"

I looked around the highway. "Steve, there's no one here. No cars, no houses within miles. No one would even know," I stated calmly.

"No, Sheri," he shouted and started the engine, waiting for me to close the door.

I slammed the door knowing the conversation was pointless to pursue. Steve just wouldn't give in, and I knew from experience that once he put his foot down, it stayed down. This was one battle I wasn't going to win. I rolled up the window and folded my arms against my chest. If I wanted heat right now, I was going to have to create it myself. I turned up the heater and snuggled deeper into my wool sweater, hoping the remainder of the drive would go quickly. The sooner we got into our new place, the happier Steve would be.

I smiled, remembering how young and impetuous I was. I was carefree and happy. Life hadn't really got me

down at that age, how naive I was, always looking for that silver lining truly thinking that doing nothing but ignoring the problems would make them go away. I knew better now that I was a grown woman with life experience and a ton of responsibilities. *Tony Robbins, don't abandon me now!* I stopped to listen to the baby monitor strapped to my side, but nothing. Bob hadn't made a sound. So back to work I went.

Chapter Four

S teve found us a little manufactured home to rent, just big enough for the two of us, my two dogs, and our cat, Woody. The new place was great. It was a split level with two bedrooms and a nice roomy kitchen. The bedrooms upstairs were small but not cramped, and the downstairs living room was big enough to entertain in. I liked this little house, and the neighbors were close enough to feel secure but not so close that your every move was watched. I was comfortable here, and I enjoyed settling in for a few days before trying to find my next job.

It wasn't hard to get an interview at a local bank while Steve and I were living in California, but once we were living in Denver, I was not so sure. Thankfully, due to my qualifications, within the week, I had landed a new job with the local bank as a teller pretty much doing the same as I had before. Steve was doing great with the vets, and I could tell he was getting some satisfaction from his job. But the nightmares hadn't stopped, and upon my suggestion, he started to see the counselor on base. I was hopeful that now he would gain some insight into why he couldn't let go of his war experience. I knew it was a tough time for him. I was certain he would never forget what he had seen or done there, but I was hopeful that he would be able to find a way

to move beyond that period of his life and become the Steve I had known in high school.

After several months of counseling and working with the veterans, Steve came home in an agitated state. He wanted to do something more than talk to veterans and help them reintegrate into society. His love for helping others was so strong, and he talked about his paramedic training again; the old dream of being a medic had been rekindled. We talked about it for days, weighing his options and looking at ways to accommodate his dream. The bottom line was that Steve wanted to go back to school for more paramedic training and then get a job and join a crew; after all, we had been through with his depression and nightmares. This felt like a step in the right direction. He was moving away from the blackness he was shrouded in, and now he was more motivated and a little happier with his new decision, and I was all for it. But in order to allow him the flexibility to study, we would have to do some heavy budgeting because we would be living on whatever I could bring home myself. We had been used to two incomes, what he made from the army, and my paycheck from the bank, but now the army paycheck would go for his schooling, and I would have to get a second job to support us. So off he went to school three nights a week while I hold down a second job at Cocoas to help with the bills.

For the next seven years, life had continued pretty much the same. Steve had a full-time job as a paramedic, often taking on double and triple shifts. He spent more time at work than he did at home. The doctors called it the Lone Ranger syndrome; he was trying to make up for the loss of lives during Vietnam by saving the lives of those around him. But there was just no way to save enough people to make up for those loses during the war. When he did come home to sleep, the nightmares had increased, and he woke screaming and trying to choke his pillow.

Things had gotten so bad for him that once in a while, he mistook me for some enemy lurking behind a tree and woke trying to hurt me until he realized what he was doing and apologized. To make matters worse, our friendship was starting to slip away. We fought more than we agreed, something that had never happened before, and I was getting fed up with his idea of me being the little woman who stayed at home with the kids. I was scared of what was happening to us, but nothing I did seemed to work. We were just two different people with different ideas of what a normal life should be. I was distant from him and disinterested it was like living with a roommate instead of my husband. I was frustrated and upset with the situation. I wanted out but didn't want to leave him. I just needed a change.

I'd been working for the bank and cocoas all this time, and I knew I wanted more in life. This couldn't be all there was. I needed a job that was challenging and fun, not something like standing at a desk all day long; perhaps something in sales where I get to talk to people would be fun. I don't know, I was so confused and unhappy I should just pick something and stick with it, but I couldn't.

Here I was, twenty-eight, and I didn't know what I wanted to be when I grow up. Don't little kids always have that planned out in middle school and then follow those plans right out of high school? I guess for me it was different. Steve's job and schooling had come first, and I had to just stick it, out but now I felt like it was my turn. Hadn't I paid the price long enough? Shouldn't what I want come first now? I had supported him while he was doing double shifts and school as well. Now he should have to support me while I figured out what I wanted to do.

I came home from work that night, determined to make my stand. I would tell Steve my decision, and that would be that. I walked into the house. It was dark, all the lights were

off, and I heard the soft sounds of sobbing coming from the living room. I walked in and flipped on the light to find Steve sitting alone in the dark, head down and crying. My heart sank, and I felt so terrible seeing him this way. I sat down beside him and took his head in my hands. I gently kissed his forehead.

"Steve, you can't go on like this anymore. It isn't getting any better."

"I just don't know what to do, Sheri," he said, wiping the tears with the palms of his hands.

"This isn't good for either one of us," I said, looking deep into his blue eyes.

"I know, but it's hard to let it all go. So much pain and loss, it was all so senseless, Sheri. Why?"

I sat back on the couch beside him. "I don't know, babe, but you've got to stop dwelling on all this. We've got problems too, Steve, and if we don't fix them, I'm not sure what's going to happen to us."

"I know," said Steve, slumping down on the couch, head in hands. "We need a change."

"All this moving around we do is not going to solve our problems," I said dryly.

"I know," he said, depressed. "Is there something you want to do, Sheri? What about school?" He brightened. "We talked about you going back before. Would you like to go now?

"Yeah, I would. I'm at a total loss in all this, Steve. I want to help you, but I don't know how to do it. I'm so unhappy in my career too. Maybe going back to school would give me some sense of control over my life again."

Steve leaned over and kissed my cheek. "I think that's a great idea, Sheri. It will give you something to look forward to, and you don't have to worry about money. We'll be okay now with my job. Do you know what area you want to focus on?"

"I'm not sure what I want to do yet, but I think I'll start by taking accounting and computer classes. I feel like I need to change my life. Maybe sales would be a good area for me. I don't know, just something different," I said, leaning my head against his shoulder.

Steve patted my arm tenderly. "I think you'd be great in sales. You love talking to people, and people seem to love talking back," he said with a chuckle.

"I think I'll go register tomorrow, if that's all right."

"It's a great idea," said Steve, rising from the couch. "The sooner, the better as far as I'm concerned."

I stopped and looked at the sky, wiping the sweat from my face with the back of my hand. It' was time to quit, the sun was beginning to set, and I gathered up my tools and put them away. I picked up the pile of vines at my feet and tossed them in the green bin. My work was finished and with it the pent-up anger and frustration I was feeling. I glanced at my watch; it was almost six o'clock, so I ran back upstairs to the little granny flat I shared with Bob, quickly washing my hands before checking on him once again. Thankfully, his eyes were open, staring at me with that smile of his. His breathing was normal, and most importantly, he'd had no seizures today. I smiled and kissed his head, telling him that I was going to make dinner now. I checked his catheter and made sure everything was in place; the bag didn't need to be emptied yet.

I always tried to keep things as normal as possible for him, checking the feeding tube, making sure there were no blockages. I still remembered the brutal fight between me and the doctors over this. He had gotten to the point where food was making him choke, and he could no longer swallow. I had been told that it was time for him to go and that I should just let him starve to death. But how could I do that? He was my husband not some stray dog. Even a stray dog gets better care in his last days than the sick do now.

Thank God Gina, Bob's daughter, had seen things my way. She was my little rock and had agreed and come down to support me in my fight for the feeding tube.

It was a two-week stay at the hospital for Bob to make sure that it was properly inserted and that we had a good pace for the flow of specialty formula. I hated to leave him there, but it was necessary to make sure he adjusted to the right formula and didn't throw up all day like he had been doing at the house. My angel caregiver, Greg, was there during the day to make sure the hospital was doing what they say they should be doing, while I spent the nights there.

I still remember Gina and me sitting in the chapel at the hospital, praying, crying, and laughing together while Bob underwent the surgery that would insert the tube into his stomach. Thank God she had been there with me. We had decided to sign a DNR order for Bob in the case of something going wrong during his hospital stay. Once he was out of surgery and everything looked good, I would have two weeks to catch my breath before it would be time to get Bob back home. In the meantime, I had to get the supplies and get ready for the new phase of Bob's care. I remember that day so well, thinking to myself that I could do this. Hell, I've walked the fire with Tony Robbins three times, jumped out of an airplane at thirteen thousand feet, all to make sure I still have my power. This should be nothing, right?

Bob smiled at me and patted my head again as if he sensed my thoughts. I kissed him again tenderly and replaced the blankets over him, tucking him in again. I set the baby monitor down, turned it off, and raced into the kitchen to help with dinner. My mom was already peeking at the roast chicken in the oven, while my father, sitting at the breakfast nook, was pouring over the financial statements from my franchise company, Bobby's Way. I picked up a knife and started slicing the potatoes and carrots to go with the chicken.

I threw them in a pressure cooker and began to make the rice, while my mother got the salad ready.

"How's it look, Dad?" I asked, glancing over at him.

"Not too bad, honey," he said, looking up. "Everything seems to be in order, but I don't know where you are going to find the extra cash to make payroll this month."

"Again," I asked, feeling frustrated and annoyed.

"You need to get some new clients."

"I know, Dad. I'm hitting the streets again tomorrow. I got a lead at the hospital. I'm going to do a follow-up with the daughter of a lady who's had dementia for six years." I set the table, putting out the silverware and cups. "The nurse at the hospital said they are thinking about putting her into a home now, so I'm going to her house to try to talk her out of it."

Dad looked up and put the paper down. "Well, if that doesn't scare them into signing up on the spot, nothing will."

"Dad, I'm not trying to scare them, just persuade them a little." I took the roast out of the oven. "I just think if they can see how professional I am, it might persuade them they don't need to put her in a home."

"It might work at that," he said, pushing the paper aside and walking over to the table to sit down. "Boy, I don't know what you're cooking, but it sure smells good."

"Dinner's almost ready," I said, putting the roast chicken on a bed of rice and vegetables. My mother set the blue Venetian salad bowl, which I had brought back from Italy, on the table and sat. I carried the heavy, green platter to the table and sat down, saying grace before we ate.

After dinner, we all sat down and talked over the finances a little more. My parents had been an integral part of me getting this business up and running. They had put up the fifty thousand dollars I needed to buy my franchise and get all my licensing. My dad was great at finances, and he had taken on the role of my company's financial officer.

These nightly powwows over the kitchen table had been a comfort to me through all of this. It was a way to have it all, my family and my work. I think it helped us all have a sense of purpose through the senselessness of this disease that had taken over Bob.

When I finally helped clean up the kitchen and say good night to my parents, I was pretty well beat. I checked on Bob, his eyes were closed, and he was asleep. I thanked God and cried a little while settling down on the couch in the alcove next to his bed where I slept at night. I couldn't bear to be away from him at night. This beautiful man I used to make love to every night for twenty-eight years was now sleeping silently in a hospital bed in our home, and I wouldn't leave, even if it meant sleeping on a very uncomfortable couch. I lay here looking at the ceiling and praying to God that I was making the right choices for Bob, asking God for a sign that I was doing what he wanted for Bob.

I prayed, "God, if you want Bob up there with you, then please take him. Otherwise, I'm gonna do everything in my power to make sure that he lives a long and comfortable life."

I listened to the sounds of the machines and began to think about the first time I had met Bob on my first day back to school all those years ago.

Chapter Five

After Steve and I had talked about my going back to college, I had decided to go the very next day. I drove down to the college and signed up for an accounting class and a computer class that would start in a week, and I was happy for the first time in a long while. On my first night of school, I walked into my computer class, one of the first four students, and I met my instructor, Bob Malvestuto. He was a charming young man of thirty-three with jet black hair and dark eyes. He wore tight jeans and a T-shirt. He looked like a short Al Pacino with that Italian accent and swagger. However, when he talked, it was another story. He reminded me of Vinney Barbarino from *Welcome Back, Kotter* the way he talked to the class.

Bob always held a cigarette in his hand and smoked like a freight train. He had a funny little trick of holding the cigarette in his hand, and he'd sit on the desk, prop his arm up on his leg, and then flip the cigarette into his mouth, filter side in. He was hilarious and made me laugh every single class period. Bob was not a stuffy formal teacher; his classes were fun and full of laughter. He was in the habit of grandly announcing after class on occasion that he was taking us all out for pizza and dancing, and then we'd all file out and meet up for a fun night. I had never in my life met anyone like him.

Under ordinary circumstances, he would have been nothing more than a nice teacher I met in class, but because of the tension and distance between me and Steve, I fell crazy in love with this amazing man. After a few weeks of sitting through Bob's class and semi flirting, I was hooked.

Steve and I had been fighting a lot lately, and after one particularly rough day, I wandered into class a little late, still stewing over our latest argument.

Bob was teaching the class as I walked in. "You in the back, in a coma, what's the difference between a bit and a byte?" He asked a terrified-looking young man with black pants and a blue shirt. He stammered a few times, trying to remember the answer.

As I was trying to slip into my seat unnoticed, Bob spied my entry and, in a loud booming voice, said, "Yo, Sheri, hey, how ya doing?"

I was mortified and still upset from my argument, so I shot back a quick response, "Hey, Bob, I'm great."

"Yeah," he asked, not really believing me. "Well, this guy in a coma here was just about to tell us the difference between a bit and a byte."

The young man stammered again and tried to feebly give a clinical term, but Bob interrupted him, shouting, "The difference between a bit and byte is the bit don't leave you with a hickey." He turned around and walked up to the chalkboard as laughter erupted from the class. Even I couldn't help chuckling and somehow made it through the rest of the class, my tension melting away with every joke Bob told.

After class, I slowly picked up my books and fumbled through my papers so that I happened to be the last one to leave. I could feel Bob's eyes on me, and I got out of my chair and mumbled out an apology for being late to class and walked toward the door.

"Yo, Sheri," called Bob as I reached the door. "You wanna go have a cup of coffee in the teachers' lounge?"

I spun around and smiled. 'Yeah, sure, why not."

"You don't have to go home right away, do ya?" he asked, laying his hand on the small of my back and leading me to the teachers' lounge.

"Nope, nothing there for me right now. Steve's working late."

"Good," he said with a smile. "Let's talk."

He ushered me through the door and down the hall to the teachers' lounge. It was small but nice, one large round table with six chairs, a counter with a coffee maker, and a small fridge. At this time of night, there was no one around, and I sat in a chair laying my books on the table beside me. Bob walked over to the coffeepot and poured two cups. He set them down on the table along with cream and sugar.

"So, Sheri," he said, pulling his chair closer to me. "I couldn't help noticing you seemed a little upset when you came to class tonight. Everything okay? Is there something I can help you with?"

I sipped my coffee slowly. "Not really, my husband and I are just going through a period of sexual anorexia."

Bob choked on his coffee and spluttered. "You're going through what?"

"Sexual anorexia, "I stated proudly. "I read it in a magazine. It's a real thing."

"Well, I never heard of that." Bob chuckled. "But, Sheri, if you got an itch you can't scratch, alls you gotta do is come to me. I can help you out with that."

I straightened up in my chair and gave him a stern look. "Listen up, Bob, I am a married woman, so you're barking up the wrong tree here."

"Hey, so am I, got two kids too," he said, leaning closer to me. "But we stopped sleeping together a year ago, you

know how it goes. We just don't see things eye to eye. It's hard to be married to someone who doesn't want what you want in life. Things happen, Sheri, and people grow apart." He sat back in his chair, smoking his cigarette and staring at me.

Inside, I was flustered and blushing at the same time. This man got it; he knew what I was going through in my marriage. Maybe I wasn't the only person this could happen to.

"I thought I was the only one that felt this way. I thought it was my fault and that I wasn't trying hard enough to make it work." I set my cup down on the table.

"Ah, Sheri," said Bob, smoking away and getting that philosophical look in his eyes. "Marriage isn't all one person. It takes two to make it work. You can't fix what's broken all by yourself. He's got to put in a little effort too."

"I guess that's true. I've been trying for years with no luck." I sadly looked down at my coffee and said, "Bob, thanks for listening. It means a lot to have someone understand what I'm feeling."

Bob reached over and held my hand. "I like you, Sheri. I'm here anytime. Don't forget that."

"I like you too, Bob, but like I said, I'm a married woman. All I can give you right now is friendship and a caring ear to listen to you. I'm not available. I got too much to sort through. I'm still trying to find out who I am and what I want."

"That's okay, Sheri, you're worth the wait." He leaned over and kissed my hand softly.

That night at home, I kept thinking about what Bob had said. It seemed funny to me somehow that this sweet caring man was having the same problems I was having in his marriage. At least, Steve and I didn't have any children to fight over. I guess our problems were not as bad as Bob's

situation. Maybe we weren't so different, Bob and I. I tried to turn my mind off and go to sleep, but images of Bob and his proposition kept popping into my mind. At least, I could have him as a friend, if nothing else.

Chapter Six

For the next several weeks, Bob and I talked more and more. We talked about life and love and the whole damn thing. As it turned out, Bob and I had more in common than I thought. He was a really good dancer, something that I had always loved but Steve hated. Bob continued to take the class out for pizza and dancing a few times a week, and during these times, we grew closer as friends talking about our spouses and trying to figure a way around the troubles we were having. Bob tried to help me deal with Steve's depression, while I tried to give advice on how to approach his wife. Our friendship was growing, and I came to depend on our after class talks over coffee in the teachers' lounge.

During one of our talks, Bob turned to me and said, "Hey, Sheri, do you ski?"

"Oh, I've always wanted to learn," I said, sipping my coffee. "But never had the chance to go. Why do you ask?"

"My company will be entertaining some guests this weekend up at the lodge. We're going to have a seven-room cabin, so I've invited a few of the students from class to come up as well. I would love it if you would join us."

"Oh, I don't' know, Bob. It might look a little funny, don't you think?"

"Teacher and students in the same cabin?"

Bob peered over his cup at me. "Nah, it'll be fine. It's being sponsored by my company, not the school. Just a few of my colleagues and you and me and some friends from the school. It's not like this is high school, Sheri. It's adult school, and nobody gives a crap."

I almost spit out my coffee laughing. "Bob, you're so funny. Okay, tell you what, I'll talk to Steve."

"What's he gonna do? Say no? You gotta stay around that empty house all day long? Besides, it's not like he's there waiting for you at home," he said, patting my hand lovingly. "Come on, Sheri"—he leaned close to me—"come away with me for the weekend. We'll have a blast, you'll learn to ski, and everything will be fine."

"I'll let you know." I smiled.

"Fair enough," said Bob, rubbing my arm tenderly.

That night, I went home and waited up for Steve. He finally stumbled in exhausted and run-down, crawled into bed, and mumbled a good night. I rolled over and lightly tapped his shoulder, but he didn't respond. He was so tired he'd already fallen asleep the second his head touched the pillow. If I wanted to talk to him, I'd have to wait until morning before he snuck off to work again.

I didn't sleep well that night. I kept waiting for Steve to wake up for some sign that he was on his way out again. I got up and went to the bathroom. I heard movement from the other room. Steve was getting ready for work again. I walked back into the bedroom to find Steve quickly pulling on his shoes; he hadn't even bothered to change his clothes.

"Good morning, Steve," I said quickly, making the bed. "I have something I need to ask you before you run off to work."

"Can't it wait, Sheri? I'm running really late," said Steve, pulling on his jacket. "I'm doing another triple shift."

"No, it can't," I said dryly, knowing from experience that if he left now without hearing me, he wouldn't be home for two days.

"I'll be back sometime Saturday night. We can talk then," said Steve, running for the door.

I followed in my nightgown, chasing after him to the front door. "Steve, this is really important. We need to talk now. There's no better time, you're never home anymore."

Steve stopped in the door, turned to face me, and said, "Okay, Sheri, real quick. What is it?"

I paused for a moment, slowly choosing my words carefully. "Steve, a few of my friends from the college are getting together for a ski trip this weekend. They are all renting one big cabin with plenty of room. The girls will bunk in two rooms, while the boys bunk in the other rooms. I'd really like to go. I've never been skiing, and this will be my opportunity to learn. So I really want to go this weekend with everyone."

"Gee, I don't know, Sheri. It doesn't sound like a good idea to me. It's a lot like football. You can't just sit on the bench. They will expect you to play the game."

"What on earth does that mean?" I said as Steve raced out to the car.

"Means I don't think it's a good idea," shouted Steve, getting into the car. He started up the motor and drove off.

I stood looking after him in my nightgown. We had become two strangers living in the same house. I no longer recognized the man I called my husband. Steve and I had grown so far apart in the last several years. We both wanted different things in life, and it became more clear to me as I watched the taillights disappear into the darkness, that this was no longer the existence that I wanted. I didn't care what Steve wanted anymore; why should I? He obviously didn't care about me either. Why else would he keep burying himself

in his work night after night, day after day, pretending that everything else is all right? No, I would go on that trip and have some fun for once, and if Steve didn't like it, too bad.

I rolled over and looked at the clock on the table next to me. It said four thirty. Two more hours and I would have to get up and start my day. I glanced over at Bob, barely able to make out his face in the dim light. His eyes are closed, and he seemed to be sleeping peacefully. Thank God for that. I rolled over toward the wall. I wasn't getting much sleep tonight, my mind was full of the past. I kept thinking about that first night with Bob, the ski trip that had brought us so close together and cemented my feelings for him. I would never forget that trip as long as I lived; Bob was the man of my dreams. He showed me things I had only dreamed of. The feelings he stirred in me were feelings I had suppressed during my time with Steve. He taught me how to be a woman again, how to laugh, and most importantly, how to love so deeply and passionately that you lose your separate identity and become one person in two bodies. In the stillness of the night, hearing those machines and watching Bob's still face in the moonlight brought back that trip so vividly like it had all happened yesterday.

Chapter Seven

I had never been to the lodge before. Steve felt it was too long a trip for the weekend and could never tear himself away from work for more than a few hours at a time. I didn't know the way, and it was snowing. Bob felt it was safer if he drove. It was a long four-hour drive into the icy mountains, but it didn't seem that long to me. Bob and I talked the entire way up about where we were born, our parents, our experiences growing up, and our broken marriages. I learned more about Bob that trip than I had in all the nights of coffee in the teachers' lounge. He told me about his business and his partner and the reason behind this trip. If everything went well with the clients at the ski lodge, it would mean a lot of money for Bob and his partner.

The road was icy and winding all the way to the top of the mountain. The further we drove, the more snow we encountered we had to pull over once just to put the snow chains on my car. We got back in the car and drove. The windows were foggy with the snow falling thick, and it was very hard to see on the winding mountain trail.

But somehow, I wasn't scared knowing that Bob was driving; I felt safe in his care. I didn't worry about crashing or going over the side of the mountain. I knew that we would reach the top safely. I was so engrossed in our conversation

I barely noticed the other cars on the road. The more Bob talked, the more I realized I cared for him deeply. In the last few months, he had become my best friend. Watching the curve of his smile, the tilt of his head, and the way he smoked that damn cigarette with one hand while driving, I was in awe. I felt like a kid again, full of excitement and wonder. Once again, I felt like that young girl that had jumped out of the car to play in the snow all those years ago.

It was midafternoon when we reached the top of the mountain. Bob parked in front of the lodge, and he ran inside to check in and collect the keys. I was stiff and got out to stretch my legs. I walked slowly into the lodge, hungry from the long drive up. We weren't the first ones to arrive. Seated inside the lobby around the fireplace were three of my classmates—Todd, Becky, and Elliott. Bob waived at them from the counter while Elliott raced up to me.

Elliott threw his arms around me. "Oh my God, Sheri, I'm so happy to see you. Are you okay? That snow was crazy. I thought we were going to die all the way up," he said, jabbering on in his most feminine voice.

"I'm fine, Elliott. No, we didn't have any problems on the way up," I said, returning the hug and patting his back to reassure him that everything was fine.

Bob came over and handed everybody a key. "Okay, everybody, here's your keys. Don't lose them. I'm gonna drive up to the cabin, and you can all follow me up. There's plenty of parking."

As we all filed outside, three more cars pulled up. They honked and waved, rolling down their windows to shout hellos at Bob. "Follow me," he shouted, pointing up the hill. We all quickly jumped in the cars and filed up the hill to our cabin. Bob was right, there is plenty of parking for the five cars. For the next twenty minutes, it was a jumble of hellos, laughing, and catching up while everyone began taking out

luggage and filing into the cabin, the boys carrying their small luggage while helping the girls with theirs.

Bob and I were the first to walk through the door. It was a beautiful two-story cabin. We walked into the living room, which had a huge cozy fireplace at one corner with several couches and chairs for relaxing in. On the other side of the living room was a big kitchen with a breakfast nook and dining table. The place could easily have seated twelve people with no problem. In the middle was a large staircase leading to the second-floor bedrooms and bath. There were two master bedrooms—one was upstairs on the corner of the house where Bob puts his client and partner, and the other was downstairs next to the living room, which Bob claimed for himself. The second bedroom off the kitchen was smaller and had three beds.

"Sheri, why don't you and Becky take that second room off the kitchen? It's got its own bathroom, and you won't have to walk so far to the kitchen in the morning," said Bob. Laughing. "I know how you girls are early risers, wouldn't want anything getting between you and your coffee at five."

"Oh, really," I said in my best tough guy voice, trying not to smile. "We'll see how you like being woken up at 5 in the morning when Becky and I bang the pots and pans at your door."

Bob laughed. "Nah, I just like teasing you girls. You'll get your privacy there," said Bob with a wink. "And if you need anything, I'm just two doors down. The rest of you," shouted Bob, dragging his suitcase into the bedroom, "head upstairs. There's girls rooms on the right and boys on the left, so you can all partner up and figure out who's you're bunking with. And don't forget they serve dinner at the lodge at five, so you have two hours to unpack and get ready." Bob smiled at me and shut the door.

I dragged my bag into the room, while Elliot ran over to Becky and me with his suitcase. "Well, odd man out, guess

I'm with you girls." He plunked his suitcase down on the bed. "Shall we unpack, ladies?"

Becky and I smiled at each other; she already knew Elliot wouldn't leave my side for a minute. He was attached to my hip, it seemed, always following me around and asking me about my hair and makeup. Our room was small with a bunk bed and just enough room to walk between that and the single bed across from it. I found the closet behind the door next to the bathroom. I opened the door to the bathroom and walked in. I was impressed with the size—it was bigger than our room with a shower, sink, toilet and vanity counter. I walked back into the bedroom to find Elliott complaining.

"God, this room is so tiny," said Elliott, trying to move past Becky.

With a big smile, I looked at Elliott and shook my head. "You're not going to be living in it. You're just going to be sleeping in it." I patted his back tenderly. "We won't be spending much time in these rooms anyway, Elliott. We came to ski."

"Well, I guess you're right," said Elliott, moving towards the bunk bed. "It's certainly not the Marriott, but I guess it will do in a pinch." He smiled. "I haven't seen bunk beds since I was a kid."

"Top bunk is mine," announced Becky, throwing her pillow on top.

"That's fine with me," said Elliott, sitting on the bottom bunk. Leaning toward me, he whispered, "I always hated the top bunk."

"I guess that leaves me with the single by the door then."

"Aww, poor Sheri, always the single girl by the door." He reached over and patted my hand. "What's wrong with that husband of yours anyway? You're quite a catch, Sheri. Don't worry, honey, someday someone's gonna snatch you up."

I smiled and set my suitcase down on the bed, pulling out clothes for dinner. "Well, he's got issues, but I don't want to talk about that. This is my weekend, and I intend on having fun."

"Speaking of fun," said Elliot with a mischievous grin, "did you see that tall, dark, hunky guy with the piercing blue eyes get out of the car? Yummy."

"I did," said Becky, climbing down off the bunk. "He was dreamy. I wonder if he's single."

"I don't know," said Elliott, grinning at her. "But I intend to find out."

"Oh, that was Bob's partner," I said with a smile as I pulled out a pair of white disco pants and a red silk shirt and carefully laid them on the bed. "He brought his girlfriend with him. Hey, you better be careful, Elliott. With an attitude like that, you're going to end up having a weekend fling that you might regret."

"From your lips to God's ears," said Elliott with a sigh. "A weekend of hot, sweaty, meaningless sex where I don't have to worry about him complaining that I didn't call the next day? Oh, honey, sign me up."

"Oh, Elliott, you don't mean that." I laughed, setting my suitcase down in the corner of the room.

"The hell I don't," replied Elliott, looking at me as if I'd slapped him.

Becky threw open the closet door and started hanging her clothes. "Oh, come on, Sheri, let the boy have a little fun. There's nothing wrong with that. We are all here for a little fun this weekend, no rules, no expectations, pure enjoyment for all of us. Now hurry up and change so we can get to dinner. I'm starving."

"Yeah, I'm hungry too." I admitted. "I haven't eaten yet," I said, remembering that Bob and I hadn't stopped for a bite to eat on the way up. We were too busy talking to

even think about food. I quickly changed my clothes in the bathroom, touching up my makeup a minute before giving myself an approving nod on the way out the door.

The rest of the party was already assembled in the living room, idly chatting with one another. Bob touched my elbow and escorted me to the door. We donned our coats and made our way up to the lodge dining room for dinner. Bob had made a reservation earlier that day for the entire party, and we filed in behind a finely dressed waiter, who ushered us to a large round table situated in the middle of the dining room and centered close to a wooden dance floor with a rocking DJ. I couldn't help but notice the large shining disco ball hovering above the floor as Bob pushed my chair in.

Dinner was amazing, we ate nothing but the best and passed around bottles of wine and tequila. Bob's clients were chatting happily back and forth with the students while everyone finished eating. I sat next to Bob and Elliot, and the whole time he was talking my ear off about his last boyfriend and wondering what style of haircut would look good on him. I looked at Bob, wishing we were alone so we could talk, but Elliot just wouldn't stop. Finally, one of the girls in the group got up and told everyone she was headed to the dance floor. Elliot stood and pulled me with him out on the floor. We danced in a circle, all of us school friends, and laughed and switched partners and did a little line dancing. It was a wonderful evening, and Bob's clients seemed to enjoy the mirth we brought to the dancing and joined in with us. Finally, I got my chance to dance with Bob, and it was great to be in his arms again, just being held close and feeling his skin and smelling his aftershave. I felt at peace; this was home to me. I finally felt like I belonged somewhere.

We danced our way through two hours of the evening before Bob reminded us that we had an early ski reservation.

As a group, we all trudged back through the snow to the cabin. Bob and I said our good nights, looking longingly at each other before my little Elliot ushered me into our room and closed the door.

Five o'çlock came quick, and we all rushed out to grab our coffee before we had to rush off for our ski lesson. Elliot took his cup back to the room to finish getting ready, while Becky went out on the porch to enjoy hers. I took mine to the big fluffy couch and sat in front of the fire. It was quiet in the cabin, and I loved being the first group up. It meant I could be lazy and take my time with my cup before I had to be around the rest of the group. I was not a grumpy girl, but it was nice to be able to fully wake up without anyone demanding my attention for fifteen minutes. I was used to the solace of my home and daily routine with the dogs. Slowly, one by one, the rest of the house trickled down, and the chatting started. Bob came out of his room and smiled at me on the couch. He walked over to grab a cup of coffee, greeting everyone in turn. Then the rest of the group joined us, and Bob's partner rushed us out the door. In hats, jackets, and ski boots, we marched up the hill to the ski lift. Bob checked us in at the counter, where a nice young man helped us find the right set of skis until our whole group was outfitted with rentals. I was the only one who had never skied before, and I was directed to the beginners' circle to the right of the rental booth. The young man directed everyone else to the bunny slopes, and I told them I would catch up.

Bob stayed while everyone else went on. I was given beginner instructions on how to move my body to change direction and what to do with the polls. It took an hour before I got the hang of it, but Bob stayed right by my side, encouraging me the entire time. When the instructor was certain I could maneuver on my own, I was released from the class, and Bob and I took our seats on the lift.

"That was great, Sheri," said Bob, nudging my arm. "You did real good. I'm proud of you."

"Thanks, it wasn't as hard as I thought it was going to be. Just tuck your knees in, lean forward, and keep your skis together."

"Hey, you make it sound easy," said Bob, putting his arm around me.

I snuggled close into his chest, smiling. "Well, it is as long as you don't fall down. Getting up was a lot harder than staying on my feet."

Bob and I laughed and giggled the rest of the way up the mountain, chatting about the day and my newfound skills. Bob decided to take it easy on me, and we chose the bunny slope, which was a little flatter and not as fast as the large hills. Some of the students had started their second run, and we were able to join them on the trip down.

I was very confident with my new skills. They all took off, and I slowly skied my way through the trees, keeping in mind what my teacher had told me about knees and elbows in. The students kept going down the hill a few yards ahead of us the whole time while Bob and I slowly made our way down.

It had been a beautiful day, and the skiing was fun, and I found my stride easy enough. Bob, my constant companion, never left my side, and we had a blast. Finally around 2:00 p.m., I was tired and needed a break. Bob was hungry and insisted we go down to eat at the snack bar before heading back to the cabin. We grabbed a quick little something to tide us over until dinner and walked back to the cabin arm in arm. I was tired but thought a nap was out of the question if it took me away from Bob. I just couldn't bring myself to leave his side, so we both washed up and changed for dinner. I wore a nice pair of blue paisley bell bottoms and a cotton baby blue top to match, fluffed my hair a bit, and reapplied my makeup. I walked back into the living room, and Bob

was sitting on the couch waiting for me. I sat sideways next to him, admiring his features, and I smiled, putting my arm around the back of the couch, draping my hand on his shoulder. He smiled and gently traced the sides of my cheek with his fingers.

"You know, Sheri, you are such a beautiful woman." He gazed longingly into my eyes, and I smiled a little. Nervousness crept into my stomach as I watched the way he stared into my eyes. "I hope you don't take this the wrong way," he said, leaning over to kiss me.

He gently touched his lips to mine, and I closed my eyes, feeling the warmth of his skin. I kissed him back suddenly, wanting to explore these feelings I had developed for this sweet, kind soul, who looked at me like I was the only woman in the world. He pulled me closer, and I didn't resist. He enfolded me in his arms as his lips took mine in a gentle and firm embrace. I kissed him with pure enjoyment and wonder. Steve had never kissed me this way, tender and searching at the same time firm but gentle, and the fire I felt at his touch was new to me. This man was so different from Steve in so many ways. Suddenly, I was hungry for him, and I wanted more. I pulled him tight into my arms and relaxed into his body. Oh, the joy of kissing this man was so overwhelming I felt alive and free again.

Suddenly, my reverie was interrupted by voices outside. It sounded like the happy group of skiers was coming back. Bob gently ended our long embrace with one last tender kiss to my lips before gently pushing me back and smiling as he moved a short scoot away from me on the couch. I flushed and tried to compose myself before the rest of the gang walked in, but I caught Bob's eye, and we both knew in an instant what had just happened was magic between us. We both laughed a little nervously and then set off into hysterics as Bob blushed.

"Like a couple of school kids we are." Bob laughed.

"I know, right?" I said, laughing. "Bob, I've never felt this way before."

The door opened, and the group burst through the door. "Sheri," boomed Elliot, "there you are. Honey, we gave up on you long ago. But here you are sitting pretty on the couch waiting for us."

"What's so funny?" Becky demanded.

"Oh, you know me, always got a few laughs to spare," responded Bob, winking at her.

"I'm absolutely starved," said one in the group.

"Then go get your butts changed, and let's eat. We've been waiting for you all for hours," said Bob with a smile.

It didn't take long; within minutes, the rest of the group was back, changed and ready to head up to the lodge for dinner. We arrived at the dining room just in time to hear the DJ start up his nightly program. A smart-looking waiter ushered us to the same table we held yesterday, and again we ate like kings while passing around the tequila and wine.

Halfway through dinner, some of the students had gotten up to dance, and I sat and watched them, while Bob wined and dined with his potential clients. I listened eagerly to the conversation, smiled, interjecting when I could contribute something worthwhile to the conversation. Toward the end of the evening, all the couples were out on the dance floor enjoying the DJ, except Bob and me and his future clients. The four of us were left alone sitting at the table, while even Bob's partner had taken his girlfriend out to the dance floor. Bob was so engrossed in the conversation with the two men next to him that I no longer interjected anything and sat watching the dancers with joy tapping my foot in time to the music.

Finally, Bob glanced over at me and smiled. "I guess we are the last ones left. If you will excuse me, gentlemen, I

have a beautiful woman to dance with," said Bob, picking up my hand and kissing it gently. "You two should get out there and enjoy the music. There's lots of pretty girls just dying to dance with you after last night's moves." Bob winked and led me out onto the dance floor. The DJ just began a slow song, "Sailing," and I just melded into Bob's strong arms.

"You think that was wise?" I asked, resting my chin on Bob's shoulder.

"What, that?" said Bob, smiling. "Nah, they were already hooked by the first course. The rest of the conversation was just gravy. I'm sorry, Sheri, I didn't realize how long it had been," he said, kissing my forehead.

The butterflies I had begun to feel in my stomach leapt at the touch of his lips against my skin. "That's all right." I smiled, looking into his beautiful eyes. "That's what you came here for. I wasn't about to break that up."

"Business is business, but when there's a beautiful woman waiting for you to entertain her, you never make her wait long. 'Cause if you do, when you finally turn back around, she's liable to be getting some other Joe tending to her needs." He laughed.

"I suppose that's true in Italy," I said, laughing. "But not here in the States. Besides, there's no other man I'd rather have on my arm than you." I laid my head down on his shoulder, and he held me tight. I felt his hand on the small of my back as he guided me around the floor with his body pressed against mine.

The words of the song drifted and fell gently around us like the soft breeze of a spring day, enfolding us in its embrace. "Sailing, it takes me away..." I looked dreamily over Bob's shoulder and spied a lovely older couple across from us. The woman was looking at me in that special way that older women have of knowing what's secretly in young folks' hearts. I perceived a gentle nod of approval and sly

smile, and I could swear I heard her say in my head, "You go, girl. Way to get your man."

"Oh, yeah." I thought back to her with a smile and dreamy nuzzle of Bob's neck. "This one's mine, all right."

The DJ, as if answering my desire to stay locked in Bob's arms, began to wind down the night with a series of slow songs that allowed us to be in each other's arms for the rest of the evening. As each song ended, we just kept the rhythm going and just flowed right into the next song, our souls merging and floating together in the melodious tones of the night, ignoring everyone around us just being in the moment. Then suddenly it seemed, the music ended, and I looked up to see we were the last ones in the room besides the wait staff, who were busily stacking chairs and getting the room cleaned and ready for tomorrow morning's breakfast.

"I think we should go," said Bob, leading me off the floor and out the door to the cabin.

We walked back in silence, holding each other and looking up at the stars. We crept quietly into the cabin, and everyone else seemed to be in bed. There were no sounds or movement coming from upstairs, and the living room was dark. Bob ushered me into his room and slowly locked the door behind us. I took off my jacket and boots, laying them on a table next to the door, while Bob quickly removed his and built a fire in the fireplace. I sat on the bed in front of him, and when the fire was roaring and the room was getting warmer, he flipped the light off and came to stand beside me. He was pale and sweating, and he seemed to be nervous as he was slowly twisting a match in his hands.

"Are you okay?" I asked. "You're sweating, and you seem like you're upset."

"No," he said, gently pulling me up to him. "I just don't know what's wrong with me, Sheri. I feel like there's something here, and I just don't know what to do. I can't

explain this feeling I'm having when I'm with you." He wrapped his arms around me.

"It's love, baby," I said, kissing his neck and holding him tight. "'Cause I'm feeling it too."

"You might be right," he said, whispering into my hair softly. "'Cause, Sheri, I never felt this strongly about a woman in my life, and there have been a few, but nothing compares to this. It feels so foreign to me. I know you're married, and I'm still figuring things out with my ex and the kids, but I just can't let you go tonight. I don't want to give you up. I'll be respectful to your situation, but I just need to hold you tonight."

"Me too," I whispered back. "I just don't want this night to end yet. I need to know this feeling is real."

He pressed his lips to mine and held me firmly, one hand on the small of my back and the other caressing my ear and neck, while he kissed me tenderly and passionately. I felt my body relax into him. Those tender yearning cries of my body were met with soft and tender caressing of his hands. Slowly, gently, he pulled my top off, and I yanked and pulled at his until our bodies were touching softly. His lips only left mine to take off our shirts, and then again they were joined in lovely waves of passion while I felt our souls unite in that tender embrace.

True to his word, Bob was respectful of my marriage vows, and he never pressed me for more than the tenderness and closeness our bodies were enjoying, lying naked next to each other. I was in ecstasy anyway; I didn't need the act of sex to feel what I had been missing in my marriage to Steve. This was what I had been missing—tenderness and understanding. Bob's hands caressed and explored my body slowly, tenderly, the way a lover should. I was encouraged to do the same, and not once did he tell me no or push me away. I felt his body firmly pressed against mine, our hearts beating

as one while he kissed and caressed every inch of my hungry body. I felt like a starving woman who had just tasted food after years of want. His kiss and touch had awakened the woman in me that I had been forced to suppress for so long. Tears slid from my eyes as he kissed me. My skin tingled and burned with passion I had so long been denied of. I was so overwhelmed with the feeling of pleasure I honestly felt as though my body would explode.

I lay in his naked arms all night long, feeling him against me and knowing this was love and that this was what I had needed all along. I didn't want the night to end; I was alive. For the first time in my life, I didn't feel like I was drowning in an abyss of despair and darkness. Here there was light again and warmth and love. This was my second chance, what I had prayed for—all those years and nights crying alone into my pillow pleading and begging God to hear me. All the nights of wondering what I had done wrong and why I couldn't be happy like everyone else. It had all been heard, and God finally sent a soul that was just as sad and hungry as I was for a little kindness and tenderness. Just a few caring words of praise or understanding, this is what I had wanted all along, and here he sent Bob to fill that void that had been left in my heart, and I felt complete again. How could I go back to that emptiness again after this? It didn't seem fair, but I knew God would not abandon me, not now that he had showed me a better life.

The next morning, when Bob and I came out of the bedroom, we were met by a chorus of voices with ohs and ahhs. Most were shocked, but a few close friends had guessed by now that my interest in Bob was more than teacher-student relations.

I blushed and moved quickly to the kitchen for coffee, while Bob smiled and said, "Hey, come on, we're all adults here. What's to see?"

Everyone giggled and teased us for a minute before resuming their conversations. Then it was over, and I had peace again. Bob kissed me as I handed him his coffee. Today was the last day, and we had to leave soon. I went back to my room and packed up everything. I was sad to go, but I had discovered my purpose on this trip, and I knew what I needed to do.

⁓

Lying on my couch, remembering all this, made the tears come to my eyes. We had come a long way since then. Bob stirred slightly, and I heard the funny gurgling sound I knew all too well. He gasped, and I jumped off the couch as his body spasmed.

I quickly grabbed his head, shouting, "Bob, I'm here, babe. It's okay, just hang on, honey."

I held his head to keep him from biting his tongue, kissed his forehead, and watched the seizures take him. I gently rolled him to the side to keep the feeding tube from ripping out of his body while holding his head gently in my hand. For five minutes, his body seized, and I waited patiently, reassuring him the entire time with my words; his eyes were large and frightened as they stared up into mine. I just kept that frozen smile plastered to my face, trying to keep him calm. It wasn't easy, and I know he had no idea what was going on. This disease had left his mind a blank and his body a mess of one medical trauma after another. I sat helpless at his side, fake smiling and praying in my head that this would not be a long one. Alzheimer's is not a pleasant disease; it is raw and ugly and strips away every shred of dignity and humanity you can possibly possess, leaving you alone and scared in a world you no longer understand, much like a baby taking its first breath, hurt and frightened.

I watched the frightened and pained look in his eyes and felt his body jerking and writhing beneath me for what felt like eternity. Then as suddenly as it began, the seizure ended, and his body slowly began to relax under me while the pained look went from his eyes, and he began to recognize me, and I could see him searching with his eyes again.

I eased him back slowly, talking to him the entire time. "It's okay, Bob, you did good," I glanced at the clock. "This was only ten minutes, babe, not a bad one at all." I smiled a genuine smile at him, grateful that he was still with me. "You had another seizure, but it's over now, and everything is okay."

He weakly smiled at me as if he understood. He settled back on the pillows, and I checked the feeding tube and made sure the line was free of debris. Luckily, I had acted fast, and it hadn't been ripped from his body. Then I placed the condom catheter back on that had come off during the seizures and kissed his lips. I laid my cheek against his for a moment, grateful that I still had my Bob. It was not a bad one, but each time he had them, I panicked, thinking I was about to lose him. I sang "Happy Birthday" to him, and he brightened and smiled, patting my head again in that sweet familiar way of his.

My alarm went off just as I finished tucking him back into bed. Wow, time to get up already, and I hadn't even slept yet. I had spent all night reminiscing about our first ski trip, and I was tired. I picked up the baby monitor, checked that Bob was okay one last time. He was drifting off to sleep again, exhausted from his morning seizure. These were a regular morning ritual now, like having my morning cup of coffee. Every day before my shower and Greg's arrival, bang, here it would come like clockwork—a seizure. I did the same thing—sit and wait praying—while I kept him calm.

51

Some days were better than others, and we got through them quickly. I thanked God out loud today was not a bad one. Now for my shower, before I had to rush off to work, Greg would be here soon, and today was a big day.

Chapter Eight

I kissed my mom and dad before grabbing my coffee to go. Greg had arrived thirty minutes ago, and I had been able to finish getting ready without worrying about Bob. I went back into my granny flat and gathered my papers from the table. "Greg, I've gotta leave now. You good here?"

A tall handsome young man with sandy brown hair and black eyes looked up from the journal he was writing in. "Yes, I'm just taking his vitals now. He siezed again today?" he asked, looking through the chart.

"Yep, like clockwork right before you got here," I said absently while checking my purse for the address to the Wickman house. "Not a bad one, this time only lasted ten minutes before he was quiet again. The tube was intact, and I put back the catheter, but you might want to check the bag. I hadn't thought to look and see how full it was before I showered." Finding the address, I pulled it out and placed it on top of the manila envelope I had in my hand.

Greg looked and confirmed it was time to change it. "Okay, Miss Sheri, I got this. You can go now. He's in good hands," said my angel caregiver with a smile.

I looked up at him and smiled with relief written all over my face. "I know, Greg, thank you so much. You're a lifesaver. I honestly don't know what I would have done if

you hadn't come to work for me. Bob loves you, and I just try to keep things as normal as I possibly can for him."

"No need to thank me, Sheri. You're an amazing boss, and I'm so glad I came to work for Bobby's Way. Bob's a good man, and I know how much you love him," he said sadly. "I just wish there was more I could do for you both, but Alzheimer's is not something you come back from."

I squeezed his hand and tried to keep the tears that threatened to rise in my eyes away. "I know, but we do what we can." I changed the subject quickly before I lost it. "Mrs. Harris is coming by this week from the state board to check things out, so I'll need you to be here with Bob a few extra hours tomorrow if you can."

"Sure can," he replied, flipping through the file on Bob's chart again. "My girlfriend got a new job yesterday, so we're going to move into that little place you suggested a month ago. Already talked to the manager, and she's giving us a month's break on the rent."

"That's wonderful," I said, leaning over to kiss Bob good-bye. "I just knew when I saw it that it would be perfect for you. And I know the area well. The Jensons live right across the street in that beautiful fifty-five and older community."

"Speaking of the Jensons, did Rosa tell you she has to go to Mexico for a week?"

"No, she didn't," I said, picking up my car keys. "When is this happening?"

"Um, I think in two weeks," he said, putting down the chart. "She told me two days ago, and I told her she needed to give you a definite day of departure and returning so that we can have Mrs. Jenson covered while she's away."

"Oh, God," I said with a sigh. "Not another shuffling of the girls' timecards. They're gonna hate us. Greg, what would I do without you here to help organize the staff?"

He bends down to empty the urine bag. "That's what you pay me the big bucks for, boss." He smiled and looked up. "I told you when you first started this business, Sheri, I got your back. It's not an easy business to take on nor is it very pleasant, but someone's got to do it. Someone needs to rescue these people from the death of a convalescent home. I've worked in them before. It's where you send your loved ones to be abused and doped up until they die of neglect. And if you try to do anything about it, you're fired. I've seen people come in, and within six months, they're gone. Just like that, no prior health issues, no dramatic medical emergencies, just dead with no reasonable explanation. It's hell in there, and people die of broken hearts and neglect. Sheri, what you're doing is noble, and I'm with you all the way."

"Thanks, Greg." I smiled gratefully, picking up my purse and coffee. "That's why I took Bob out of those places. He didn't understand what was going on. Here he is losing his mind, and he wakes up in a strange place with no one he knows, scared because he's not being talked to like a human, and they are trying to forcibly restrain him. I don't blame him for trying to escape. I would have tried to scale that twenty-foot wall myself. I'm just surprised he didn't hurt more of their nasty orderlies than he did. I was seriously cheering him on, "Go, Bob," when they told me what had happened.

"I was appalled, Sheri, when I heard about it. I can't believe that grown men would tackle a patient to the ground, put him in a straight jacket, and send him to a mental facility where he was strapped to the bed and drugged so they could make him docile and handle him as they call it. I know Bob well," replied Greg, rubbing Bob's hand and smiling at him as he raised it to greet Greg with his usual pat on the head. "He would never have been violent if he knew what was going on. Hey, buddy," said Greg, looking down at Bob. "How's it going today?"

Bob smiled brightly and patted Greg's shoulder, mumbling under his breath. Bob hadn't been able to carry on a conversation with anyone for two years. His normally boisterous way of speaking had been replaced by guttural mumblings that never made sense, so we all learned to read his facial expressions and body langue to derive his meaning. Bob had his own way of letting us know we were doing a good job with him, and any good action from us resulted in the pat on the head and a bright smile. This was our positive reinforcement from Bob, and he never failed to shower praise on anyone for doing something he liked.

"Well, I better get out of here so I can get a few more clients for us to make some money with, or we're all gonna be out on our ass, you, me, and the other five girls I have working for us."

"Good luck, boss." He smiled as he switched the bag.

I leaned over Bob and smiled so he could see me. "You're doing a good job, honey." Bob patted my cheek, and I kissed his hand, which elicited another big smile from him. "I'll be back soon. I have to go to work, but you keep an eye on Greg for me and make sure he's doing a good job, okay?" Bob smiled again and patted Greg's arm as if to say, "Yeah, no problem. I got this."

I kissed Bob one last time and left. It was hard to tear myself away from Bob some days. It was hard to think of anyone looking at this sweet man and trying to hurt him or confuse him by using violence to get what they wanted out of him. Just seeing him calm and peaceful at home was all the thanks I needed to be sure I had done the right thing. The way he responded to Greg and anyone else who used patience and love around him should have been proof to any judge that Bobby's Way gets results that are more humane and loving with its patients than any state nursing facility. Unlike their six-month death ratio, my clients live long and

healthy lives right in their own homes surrounded by family members. Nobody dies alone at Bobby's Way.

I got into my car looking at the address of the next potential client. The Wickmans were a nice couple who were struggling. Mrs. Wickman's mom had been diagnosed with dementia six years ago, and the disease had progressed to the point where she would forget how to get home from the store and would get lost on busy streets. Her son had moved in with her to help out but wasn't giving her the best care. And her daughter was torn between putting her mom in a home or moving her into her home. It had been a few months since her brother had announced he was done taking care of her, and now her mother was her problem. He was selling his mom's house and wanted to travel, so he couldn't possibly be bothered to care for her now. He suggested she be put in a home.

Fortunately for Mrs. Wickman, I had overheard her on the phone with her brother last week on one of my weekly solicitations at the hospital for clients and had passed her my card. Her husband didn't seem to be ready to have her aging mother in the house now that she couldn't be left on her own. But I was about to show them how cost-effective it would be to have their mom stay with them rather than be fully committed to a nursing home.

I pulled up to the house and got out. It was a nice little place and reminded me heavily of the house Steve and I had looked at that fateful day when I decided to end our marriage. I knocked at the door and was let in by a very lovely older woman in a pink suit and with silver hair. She ushered me into the living room and sat down on a chair facing the fireplace. A much younger woman with blond hair came running out from the bedroom.

"Mom, I've told you before not to answer the door. You never know what kind of crazy person could be there."

I smiled and shook the woman's hand. "Hi, I'm Sheri from Bobby's Way. We spoke at the hospital, and I phoned you yesterday."

She graciously shook my hand and smiled while her mother piped up, "Well, a lady holding a folder with a bunch of papers isn't likely to brain me to death with them." She said this sarcastically, folding her arms.

I laughed and smiled at her tenderly. "No, I'm not, dear. You're right, I'm harmless."

"I'm so sorry about my mother," she said softly. "She doesn't understand we're looking out for her own safety."

"I have dementia, I'm not a child," she shouted. "I was able to live on my own for twenty years without anyone telling me how to answer a door, thank you very much. I shopped and took care of myself and two kids all by myself, so good thing I have you now to wipe my nose, or my head might fall off."

I stifled a laugh and tried to keep a straight face, but Mrs. Wickman was beyond flustered. She kept trying to apologize for her mother, who only got more upset with every excuse she tried to give me.

Finally defeated and ready to give up, Mrs. Wickman said, "Mother, why don't you go take a nap, dear? You're getting overtired."

"Oh, so the child is being dismissed, isn't she? I live just fine for twenty years without a husband telling me what to do, but now I come here, and it's 'Sit down, Mother,' 'Don't leave the house, Mother,' 'Let me cut your meat, Mother,' 'Don't answer the door or the phone, Mother,'" she screamed at the top of her lungs.

"It's for your own good," said her daughter, exasperated.

Her mother was screaming again. "I know what's best for me! I'm not the child you think I am. I have dementia, I'm not an idiot!"

I couldn't watch this anymore; it was a travesty. The mother was right, she still had her wits and dignity about her, and I couldn't in good conscience sit here and watch this go on anymore. It was clear what needed to be done; her mother did not belong in a home at all. The irritable behavior that Mrs. Wickman explained to me on the phone was of her own creating. Her mother was merely responding to the indignity her own daughter was bestowing on her. I had seen enough; this interview was finished.

"If I may," I interrupted before Mrs. Wickman had a chance to hurl one more well-meaning insult at her mother, "I have to agree with your mother. From what I've just witnessed, she's perfectly capable of handling her own affairs. In time, she may need more help than she currently needs, and at that point, I still think she can be able to live comfortably on her own with an angel caregiver."

Her mother clapped her hands and became excited, rocking back and forth in the chair. "Ha! You see, she agrees. I'm not stupid, not a bit." She pointed her finger at me and smiled. "I like you."

I smiled. "I like you too. Now let me ask you a question. You have dementia, and you know what that entails, but your daughter is concerned and rightly so for those days when you have memory lapses. I'm sure that you have thought about your condition, and might even have made some plans of your own, so what would you like to do?"

She brightened up and looked at me intelligently. "I want to thank you. For the first time since my arrival, I haven't been talked down to or treated as an inferior. You're right," she said, looking over at her daughter. "I have thought it over many times. I know what I'd like to do. That's why I came here, to talk to you about it before you and that man started treating me like a child."

"Please tell us." I encouraged her. "You have her here, and she's willing to listen, I think, instead of talk over you now."

"I don't want to be treated like a child or put in a home where you'll just forget about me. I want to stay with you and spend time with my grandkids before I forget who you all are. I know my dementia has progressed, and I'm here because you're all right. I shouldn't be alone anymore, but I don't want to hamper your life either."

"Well, there you have it," I said to Mrs. Wickman. "Straight from the lady herself, and I have the perfect solution for you. I suggest we have an angel caregiver come in three times a week to stay with your mother on a trial basis and see how that works. She'll just be shadowed, not interfered with. My angel will just be here in case she's needed, and if not, then you've made a new friend to go shopping with. She can drive her to appointments and take her out if you're busy. During those times, you and your family have the opportunity of doing what you need without the worry or wondering if she's forgotten the way home."

The ladies agreed, and the papers were signed, and I left the house having been able to let her mother have her say and still make sure we took care of the daughter's concerns as well. Now she would be safe, and her quality of life had been preserved. This was what I was all about at Bobby's Way. I made my way out to the car.

I had started this company because I was already caring for Bob, so I figured I might as well get paid for it. I had been to nursing homes and care facilities while I was getting my credentials. I had even seen firsthand the kind of treatment a loved one received as a patient there. I had against my will put Bob in one for a week while I started this franchise. I remember being there and seeing the patients doped and drooling, not knowing where they were or how they got

there. When I returned to pick Bob up, I found him tied to a chair, slumped over to the side, and drooling so high on downers he didn't even recognize me. I was so upset I vowed never to make him go to a place like that again. But I had also seen my greater mission while I was there, which was to spare everyone else I could from such a fate. That's how this crazy ride had started, going mach two with my hair on fire, checking on Bob and getting other people who felt the way I did to join me. I had found Greg in that place where I left Bob, and I stole him away to help me start this company. Then with his help, I found five other really good caregiver girls, and we even convinced a few clients to put their loved ones back into their homes again with our daily supervision. God had this plan for me from the beginning. All I had to do was embrace it, and away we go.

Chapter Nine

After that ski trip, things went from zero to sixty with Bob, and I was ready. No more excuses on my part; I wanted him, and any chance I had to be alone with him, I took advantage of. I had tried to talk to Steve when I came home, but he didn't even notice I had been gone. He kept putting me off when I tried to talk to him. I told him we needed to work some things out if we were going to stay together, but he rushed past me and out the door every time, so I let things go for a few weeks. Instead, I focused on me and my needs as a newly awakened woman. I decided to go after what I wanted. My marriage was over in all but paperwork now. Steve had even been sleeping on the couch the last few weeks in order not to wake me up, he had said, but I suspected he felt the distance between us just as acutely as I had. I considered myself a free woman. I started looking ahead to my graduation and the road that lay ahead of me, and I liked it.

I could see Bob and me sitting together on a porch in old age, still so much in love. We resumed our nightly powwows in the teachers' lounge and on the dance floor. Bob still took us out for pizza and dancing every week, but instead of going separately, we went together, and by now the secret was out. Everyone knew that Bob and I were an item. He would drive me home late at night, and I wouldn't

be able to keep my hands to myself, grabbing and touching him the entire time.

Bob would be sitting there driving and laughing at me, saying, "Hey, Sheri, where you going? What you doing there? Hey, now you're a married woman. I respect that."

I would be kissing him and pulling him into my arms, laughing and saying, "I know what you're doing to me. You're making me want you even more."

"Yeah, of course, I am. That's the point," he'd say, finally pulling me into the backseat where we'd make love. Then I'd go home to that dark empty house and sleep alone, waiting days sometimes for Steve to come home.

The last week of school, I had been slammed with finals, and my mind and body were a glow with love. I was distracted and not really thinking about Steve at all anymore. I had my own life now, and I was happy. I had just gotten home from school when Steve came running to the door to meet me.

"Sheri, I got some great news today," he said, grabbing my hand and pulling me back out the door.

"What is it?" I asked, catching his excitement.

"I have a surprise for you," he said, leading me to the car. "Come on, get in. I have something to show you."

He drove down the road about ten miles and then pulled into a small driveway and up to a little house with a small yard. Steve jumped out of the car and yanked open my door.

"What are we doing here?" I asked, confused as he helped me out of the car and ushered me up the steps to the front door. "Are we visiting a friend of yours?"

He opened the door and turned on the light, pulling me inside. I looked around at a nicely furnished living room with a beige couch, a fireplace, a love seat, and a black armchair. I stared around the room, confused.

"Whose place is this?" I asked, looking at Steve's beaming face.

He held my hands and stood in front of me. "Sheri, I have been saving up to buy a house, and now I can finally afford it. I put a down payment on this place today. Now you can quit your job and stay home for good this time. No more work, no more stress about money, now I can finally give you the life I always promised you we would have." He looked down into my eyes so lovingly and kissed my forehead, laughing like a school boy. "And, Sheri, I want us to start a family, four, five kids at least." He laughed again. "Oh, Sheri, our dreams are all coming true finally. What's wrong?" he asked, catching the look on my face. "Aren't you happy?"

I was reeling; Steve had completely caught me by surprise. All I was thinking was, *My God, I'm trapped.* I felt like I was drowning right here surrounded by four walls and my sweet Steve. I gasped and trembled; all I wanted to do was run out of the room and right back into Bob's arms. I didn't know what to do. I was choking right there in the living room. I felt the walls close in, and suddenly I couldn't breathe, and I fainted.

When I came to, I was lying on the couch, Steve standing over me with concern on his face. "Oh, good, you're back," he said, checking my eyes and vital signs like a true medic. "Sheri, I don't have to take Psych 101 to know that's a bad sign."

"I think we should talk about this at home," I said, rubbing my head and getting slowly to my feet.

"We are home," said Steve dryly. "But considering the great shock you just had, I think maybe I should take you back and put you to bed. It's been a big day, and we can talk tomorrow when you're feeling better."

I wanted to talk things over and tell him my feelings and my frustrations during our marriage. I no longer wanted

this cookie cutter life he had planned out for us, and really, if I was being completely honest with myself, I never really did. I let others tell me what I should want. I was pushed into this marriage, and now all I wanted was to be with Bob. I had fallen so deeply in love with him that I knew I could never give him up. I was hooked; Bob was the love of my life, and nothing Steve could say would change that fact. I decided Steve was right; I'd go home to bed and tell him tomorrow as gently as I could that we were over.

The next evening, I had no classes, so I decided to cook a nice meal for Steve and me. It had been such a long time since we had sat down together. I thought it might provide the right atmosphere to start a serious discussion over, so I broke out the good china and the candlesticks. I made all of Steve's favorite peas with those little pearl onions and a ham with gravy and stuffing, a nice big salad and corn on the cobb; it was a meal fit for a king. I felt bad for what I was about to do, but deep down I think Steve knew it was over. I poured the wine and set the table, arranging the covered dishes and sitting down to wait. It wasn't long before the door opened, and Steve, true to his word for the first time in our marriage, was home for dinner.

"Wow, it smells so good in here, Sheri," he said, taking off his jacket and washing his hands at the sink. "Mmm, I see all my favorites out there looks great. Can't wait to dig in."

"Well, it's all ready to go," I said, dishing up a plate.

Steve sat down next to me and picked up the ham and stuffing, giving himself a generous helping. "So now that you're feeling better and had some time to think, we should talk about the house I showed you last night."

"I agree," I said, ladling the gravy over my plate.

Steve interrupted me. "So now we have the house, I think we should move this weekend after you graduate. I'd do it now, but I understand you're in the middle of finals,

and I want to be sensitive. I know it was a shock, Sheri," he said, piling his plate with food from every dish. "But we've been talking about it for years, and I've worked so much overtime now that we can finally afford it." He grabbed my hand across the table and looked into my eyes. "And, Sheri, baby, it's perfect. I didn't get to show you, but it's got three bedrooms, so we can have children right away. We can start tonight."

I sank down in my chair, feeling defeated again. He just rambled on about the rest of the house, the furniture he had bought, and what our new lives would be like with kids, and with every moment, I felt the screws tighten in my coffin. I felt the room spin again, and I could swear I was underwater drowning. I saw my life flash before my eyes, and in it was Steve and five kids with two dogs and no work. Me the little woman, making food and tending to their needs while I lost who I am and who I had become. My nights would be spent pouring over homework and driving the carpool for sporting events, driving a minivan for God's sake while I wait up nights for a husband who never comes home and dying a little every day. *No!* I screamed in my head. *Not again.* I had been down that road, and I knew where it ended.

I gathered my courage in desperation. "No, Steve, I can't do it," I blurted out.

He suddenly looked up at me. "What?"

I slowly leaned forward and swallowed, choosing my words carefully. "I can't do any of it. We've been going through a rough time, hon, and I'm not even sure you're aware of it."

Steve blinked and put down his fork. "Sheri, I know we've been struggling with money, but that's all over now. I just told you we have plenty. It's all settled now. I know you wanted to do something more with your college work, but don't you see it's not necessary now? We can have our family, Sheri, right now, no more waiting, tonight."

"No, Steve, you don't understand. You and I are not married. We've been living like roommates for so long. I don't want this life anymore. I can't do it. I want out."

"But, Sherie, I love you, and we can make it work. I'll work on coming home more. I know you love me too."

"Yes, Steve, I do love you as a friend. You were my best friend in the whole world, but don't you get it? We can't make a marriage work off of that. I'm just not in love with you, and I don't think you're in love with me either. You're in love with the idea of me in your head, and, Steve, I'm not that woman."

"We can overcome this, I know we can, Sheri." He looked into my eyes so adoringly.

I knew I would have to resort to drastic measures to make Steve understand the gravity of the situation. I did not want to do it, but I knew it was the only way to make him realize we were over. I had to tell him about Bob.

"No, babe, we can't just move on and fix this. I've done something, Steve, and I know you'll never be able to forgive me."

He reached for my hand. "Aww, Sheri, I can forgive anything, baby. I love you, and I know you didn't mean to do it."

"Steve, I had an affair." I didn't know how else to say it other than to just blurt it out; subtlety was not working.

He dropped my hand, his eyes got big, and I saw fire flash in his eyes. Then this sweet man whom I had never seen a drop of anger or violence in took his arm and knocked everything off the table in one sweep and then picked up the table one-handedly and flipped it with no more trouble than a piece of paper. I jumped out of my chair, and he crossed the space between us like an angry tiger and grabbed a hold of my neck, pinning me against the dining room wall.

He was screaming at the top of his lungs. "Why, Sheri?" Hot angry tears slid down his face.

I gulped and tried to speak through the vice-like grip he had around my throat. "Because you and I have grown apart all these years," I stammered, "I needed someone to end the loneliness."

He tightened his grip on my throat, and a small squeak escaped me. I couldn't speak anymore. He cried more and screamed while I waited, not knowing whether he would kill me or let me go, but to live without Bob, I might as well be dead anyway. I struggled to breathe, and the room began to spin again, and I felt that drowning sensation like I was going under for the last time, never to rise again. Then suddenly, Steve dropped to his knees and cried big heartfelt sobs the same I had heard all those years when he would think of his time in Vietnam, and I knew it was over. The violence and rage had left him, and he was once again my sweet Steve, hurt and full of remorse.

I touched his shoulder, and he grabbed my leg, hugging it tight. "I'm so sorry, Sheri. I didn't mean to hurt you. Are you okay?" he asked weakly, looking up at me like a child.

"Yeah, I'm fine. It was a shock, that's all I understand. I took you by surprise." I went to the couch, and Steve followed me. We were sitting side by side, his head in his hands, the way he used to do all those nights I'd come home to find him crying.

"God, Sheri, what happened to us? How did we get so far away from each other? I don't get it. I really thought everything would be okay."

I patted his back tenderly. "I know you did. I kept trying to tell you we had issues and needed some time to work through them, but, Steve, you always brushed me off, and I felt unloved and unheard. I missed my best friend."

"I'm so sorry, Sheri, I didn't realize you felt so alone. I thought I was doing what was best for us as a family, you know, providing for your needs and building a better life for us."

"I know, babe, but I never wanted any of those things," I said tenderly. "I just wanted to be me. And honestly, I've felt more alive and more me than I have ever been. Steve, I don't think you have ever liked the real me. You saw an image of the girl I was in high school, and you tried to keep me that way ever since. You know that girl in the woods all those years ago who jumped out of the car, stripped naked, and played in the snow?" Steve nodded his head at me. "Well, that's me, babe, that's who I am. I am spontaneous and free. I love to dance and fly by the seat of my pants. I go where life takes me, and I roll with the punches and rise with the good times. That's the woman I am, and I've come to love her and understand who she is and what she needs in life to be happy. That image of a nineteen-fifties woman who stays at home and loves driving the carpool, well, babe, that's just not me. I'm no June Cleaver. I want to see where my life takes me. I want to travel and explore things I've never seen or heard of, not be stuck in a house for the rest of my life."

"So what do we do now?" asked Steve, looking up at me tenderly.

"Now we have some things to work out. You just bought a house without talking to me, and I know my name's not on it."

"No." He sighed. "I thought it would be a nice surprise. I'm sorry, Sheri."

"To be honest, I've been thinking about this for a while, and I'm going to be okay on my own. You need to focus on you. I have watched you slide far from the Steve you were. You need to find something that blows your hair back and go with it, babe. You've really lost the joy in life. All you do is work and fight against the ghosts of your past. But, babe, move on. You used to love playing the guitar. Why don't you pick it up again, find something to do outside of work, get a few friends, go out and eat, go bowling, something, anything that will bring

back your joy? Because, Steve, you can't go on like this. You're gonna burn out and die a very young man if you don't."

Steve had been watching me this whole time, and I saw a glimmer or two of the man I had married, and I had hope that maybe he would come out of it for his own sake. He shook his head as if he had just awakened from a bad dream and smiled at me. He patted my hand and leaned back on the couch.

"I'm so sorry, Sheri. I had no idea what I was putting you through with all my PTSD problems. Here I thought I had been sheltering you and keeping them to myself so that only I was affected. But I see now what a mistake that was. I pushed you into a life you never signed up for. I think you're right, I needed this wake-up call, Sheri, and I'm so sorry for what you've been suffering through. I'm gonna change, you'll see. I'll be better, I'll get my life back, baby. I'll be the man you married again, I promise."

"That's great, Steve, I hope you do. You need something that makes you happy again, and whatever that is, I hope you find it soon. But I just can't deal with this anymore. I've tried to help for years, and all that happened was it got worse. You need help from God, the military, whoever it is that can reach you, but that person is not me. I need to piece my life back together, and so do you. I think it's best that we just part as friends and go our separate ways."

"I still love you, Sheri. I think I always will," said Steve sadly, looking into my eyes.

I patted his hand and hugged him tight. "Steve, you will always be my first love. Nothing will ever change the fact that you're my dearest friend, and I don't ever want that to change between us."

"Neither do I, Sheri," he said, holding me tight. "I'll go stay in the house for now, but, Sheri, I'm not giving up on us. I think I can change and find that man again, and when I do, I'm gonna come looking for you again."

I laughed and started to cry. This was bittersweet for me, and I smiled at the sweetness of this lovely man. I wished I felt the same about him, but I just didn't. I had found my true love in Bob, and I knew it was meant to be. I gently rubbed Steve's back, not wanting to crush his tender hopes that he was clinging to for dear life. I had just shattered his happy world; I couldn't take his dream away from him too. He would need something to work for in the coming days ahead of him. I knew it wouldn't be easy for him, and I still wanted to be there for him as a friend. I still cared very deeply for Steve, and I always would.

"Okay," I said, kissing his cheek before standing up.

He smiled and patted my hand tenderly and then got up and packed a bag with all the things he owned. "Sheri, I'm gonna go now, but I wanted to ask you if it's okay to come to your graduation. I still care about you, and I want to be there."

"Oh, of course, you can," I said with a smile. "I would love it if you could make it. I still want us to be friends after all of this."

Steve smiled brightly. "Good, I'll be there, and, Sheri, I'll be checking on you periodically. You know, making sure you have everything you need."

"You better," I said, laughing. "I don't want you disappearing off the face of the earth now."

"No, I won't," said Steve, hugging me once again. "I promise I'll see you soon. Take care of yourself, Sheri." He left the house, military duffel packed to the max.

"Sheri, what are you doing?" came the sound of my mother's voice followed by knocking on the car window. "Are you all right in there? Should I call Greg? Are you hurt?"

I looked up and laughed, opening the car door. "I'm sorry, Ma," I said, getting out of the car. "I didn't see you there."

"I gathered that," my mother said, a little annoyed. "I've been calling you since you got home. Thought maybe you were having a stroke or something, so I came down to check on you."

"I'm sorry," I replied absently, gathering my papers and files on the Wickmans' mother. "I was just thinking about Steve all the way home, and I guess I got lost in thought when I pulled in. I didn't mean to scare anyone."

"Why were you thinking about him again?" asked my mother.

"Just been thinking a lot lately about the past and what happened in our lives. Plus the house I went to today looked so much like the one Steve had surprised me with. I guess it just started me thinking again." I followed my mom upstairs to the house.

"Oh, well, your father's been expecting you. There were a few calls while you were out."

"Okay, Ma. I'll be right there. I just want to go check on Bob and Greg real quick."

"All right." She walked across the deck and into the kitchen while I turned to the left and went into the granny flat and laid my papers on the table. I glanced at the clock on the wall in front of me. I had only been gone three hours, but it had been a productive three hours, and now all I had to do was go over the timesheets with pop and figure out who would be best to send to the Wickmans. So many things to do when running a company, but I didn't mind; this is my life, and it had been a good one. I had paid my dues and struggled most of my adult life, but I had learned one thing through it all—God was watching and taking count of what I had invested in people over the years. All the love and patience I freely gave had not gone unnoticed, and he had paid it back in spades.

I glanced around the room and saw Bob awake and looking at the television. I thought once more of my time with Steve, and I remembered how happy he had been to start playing guitar again. He had even called me one night so happy that he had gotten a small weekend job playing at a local diner. I had gone down to see him play and was so proud of the progress he had made. Of course, he asked me back home thinking now everything was patched because he had made progress. I had to let him down easy. He took it well, though, to his credit, and we remained friends the rest of his life. I knew Steve was destined to find that right woman for him, and I told him so many times. Six months after our eventual divorce, Steve finally met a wonderful lady, who was also a paramedic, and later in life, they had two beautiful children. But he still checked on me from time to time, and even after his sad death a few years back, his mother still wrote to me, making sure that I knew I would always be in her prayers.

I smiled watching Bob's eyes captivated by the light on the TV. I wouldn't change any of it—not my time with Steve or the life I led with Bob. We had a great one, and it's not over yet. I was in for quite a ride, and I was strapped in and hanging on for dear life. God was in control of this rollercoaster, and as my jump instructor said when I jumped out of the plane on my last birthday, all I have to do is raise my arms up and enjoy the free fall and then pull the cord and let God do the rest.

Chapter Ten

The telephone rang, and I jumped to answer it. Bob said he would call after his meeting and let me know how it had gone. If he got this job with Hewlett Packard, we would be moving to Milan, Italy, for two glorious years. Who wouldn't want to live in Italy? After all, it was romantic, full of old cathedrals and castles. It was the fashion capitol of the world and the birthplace of Italian sports cars, every woman's dream. If we moved, I had imagined myself clad in the latest designer clothing and driving around, waving and saying, "Ciao" while indulging in the best Italian food and wine available. Oh, this was gonna be great. I sat at my desk, praying, while Bob was going through the meeting. I had jumped when the phone rang, and when I picked it up, I heard Bob's voice on the line.

"Hi, honey," I said breathlessly.

"Baby, we're going to Milan. Pack your bags and say good-bye to your family."

"Oh my God," I screamed into the phone. "You got it! We're really moving!"

"Yep, we got a month here to get everything in order before we're expected at the villa. Company takes care of everything, flights, moving expenses, a train pass to get to and from work, Italian villa, and a cash allowance for food and sundries the first month until I get my paycheck."

"Oh, Bob, that's wonderful," I shouted into the phone. "So don't worry about dinner. I'm taking everyone out. Might want to give your notice today. That way we can leave together instead of having to wait and take separate flights."

"I will, babe. Right now, in fact," I said, clicking on the computer screen to type my letter of resignation.

"Don't think Tony's gonna like me anymore, taking away his National Franchise Manager," said Bob in a teasing manner.

"Well, I did warn him it might come," I said, holding the phone on my shoulder while I typed. "So it's not like it's a big surprise. I've been helping the lawyer look for a replacement the last few weeks just in case."

"Okay then, Ms. Manager, I better let you get back to it then. I'll see you tonight at dinner. Pick you up at home six o'clock sharp," said Bob with a chuckle.

"Okay, honey, I love you. Bye," I said, hanging up the phone and finishing up my letter.

I checked the spelling and made sure the letter looked professional before leaving my office to chat with Tony Robbins. Not quite sure what to say to him, I thought of a million different ways to start but couldn't find the right words to say. I sat at my desk, dumbfounded, and looked out the window. I mean, how do you say good-bye to someone who's helped you through one of the toughest times in your life? A friend who's taught you how to let go of your inner fears and free your mind from the obstacles society has set up to control and inhibit you from becoming everything you are capable of achieving? Tony wasn't just my boss; he was a friend and mentor to me. I looked up to him, and he had shared two years of my life helping me through being a stepparent and showing me how to unlock that inner confidence I had lost after Bob and I had gone broke and were living in that house in La Jolla with no furniture. We

had both struggled to survive with two kids and no work. We had spent everything we had to buy that house, and then Bob's partner had stabbed him in the back and taken everything, leaving Bob and I penniless.

I sat reminiscing about it all. We had a difficult time getting through those first five years after my divorce from Steve. We still hadn't been able to be together. From the start, Bob had a long drawn-out divorce that left him drained. And me, I had been all over the place trying to start a new life that included Bob, his two children, and a beautiful ex-wife that I would be co-parenting with. It was definitely a process, but we all got along for the children's sakes, and before long, we had a well-oiled machine of parental love flowing that eventually led to sisterly love between me and Bob's ex-wife.

We had finally gotten everything settled, and Bob and I decided it was time to get married, and we did. It was a wonderful ceremony, and we had a great time of it. Typical of an Italian wedding, you had your big honchos standing around in sunglasses, calling their cronies to make sure no one was coming to ruin our big day. Ha, it was a riot. You would have thought Bob was the head of the Denver mafia the way these guys acted, but everything went off without a hitch, and we partied the afternoon away. A few short years later, we had bought a house in San Diego in a little area called La Jolla with the money Bob had saved from his blossoming company. I had been trying to get my realtor's license while we were in Denver, so I had decided to carry that over to California. We could easily live on what Bob was bringing in until my license came through. We had sold our furniture and most of the household goods to pay for the trip out to our new home. Bob said we'd start over in San Diego all brand-new things for our new house, so only the absolute necessities were packed into our little car, and we were ready to go. However, a few days before the big move, Bob's partner

had decided to cut Bob out of the business, stealing clients on the side, and eventually he succeeded in forcing Bob and the company into bankruptcy. Bob was devastated, but more than that, we were now broke and out of our home, and I had left my job before the move. Bob and I faced facts: we both had family in California and a brand-new home already, and we knew it would be tough, but we couldn't stay anyway, so we packed up the kids, drove out to San Diego, and lived camp style in our own La Jolla-style mansion.

I smiled to myself, looking around my plush office here, thinking about those early days with Bob. It had been a rough time for us, but we never got down or depressed; just doing what we had to do to survive and always finding the humor in the situation kept us from feeling like we had been deprived of anything. I got a job in a dress shop for a few hours every night while trying for my new California real estate license. Bob took a security job at Casa De Manana and helped his uncle during the day. Bob's uncle, Frank, was an inventor for NASA, and Bob was helping him promote his new Turbo Wing System. Things were tight, and when we moved into the house with no furniture, we had told the kids it would be an adventure; after all, how many kids could say they get to camp out in their living room every night? I'm not sure if we convinced them, but we, at least, made it fun for them. With a few sleeping bags and a couple of lawn chairs in the living room and the boxes we had brought of personal items from Colorado, we slowly bought what we could from the goodwill and garage sales as we got money. It was slow-going, but eventually everything turned out fine.

I smiled to myself, thinking over all this again. We had gotten through that period of our lives, and I had been lucky to land this job with Tony Robbins. Bob had still been moonlighting with his uncle and the security job until this offer from Hewlett-Packard (HP) came along. It seemed like

the perfect opportunity for us, and now that the kids were in college and pursuing their own dreams, it was just the two of us here to worry about. Thank you, God, this was a gift to us, and three years in Milan, who could be upset over that?

I stopped my reverie and worked up the courage to finally go tell Tony. I took my letter of resignation in hand and slowly walked down the hall to his office. I knocked and waited for his invitation.

He looked up from his desk. "Hey, Sheri, come on in, have a seat."

I walked in, flushed with mixed emotions of joy and sorrow, sat in the chair, and looked across the desk, my hands trembling. Tony smiled wide.

"I have something for you, Tony," I said with a look of sadness.

"So this is it, Bob got the job," he said matter-of-factly with a smile. "And you're here to present your letter of resignation, I assume, that's in your hand."

"How did you know?" I said, taken aback.

Tony laughed. "Sheri, I thought you knew me by now? I can read your body language like a book. You're normally so happy with a little bounce in your step and always a smile on your face. Today your cheeks are flushed, and you walked in with a heavy step and no smile. Since I knew the possibility of Bob getting that job in Italy was coming up, it didn't take a genius to see that he had gotten it." He sat back in his chair with a smile as he looked tenderly at me.

"Boy, you sure did nail it," I said with a smile, a little sadness creeping into my voice. "Tony, you just have no idea how grateful I am to you. You are so much more than my boss. You're my friend too. I don't know what we would have done without your kindness."

He held his hand up. "Aww, Sheri, please, I did nothing more than offer a very qualified woman a very good paying

job. You got the job on your own, but the friendship was a gift. I like you and Bob. It was easy because you're good people that just had a rough hand dealt to you. You have nothing to be sad about. It's time to move on and up to bigger and better things now. Isn't that what I'm always training and empowering people to do?"

I took a moment to smile and remember what he had taught me over the last two years. "Yes," I said reluctantly, "but I'm still going to miss my friend."

"Well, that can be cured with a phone call every so often." He laughed. "So how long do you have before you leave?"

"A month," I said, giggling. I filled him in on all the details of the job and what it was gonna take to get everything sold or put into storage that we couldn't take with us. I was so excited, and he shared in my happiness, and we chatted like old friends instead of boss and employee, but that was always how Tony was. You never felt like a stranger around him.

That night at dinner, Bob and I were happy. He had taken my parents out to celebrate with us since the kids were away at college. We dined and danced our way through the night. I hadn't seen Bob so happy like this since we came to San Diego. It had been such a weight on him, and I saw now the relief in his eyes. Our troubles were finally over. There was so much to be done in the month we had before we left. It was just a long run of lists and things to sell and buy. We needed converters for all of our computers and phones, not to mention I needed to bone up on my Italian. In the end, we decided to sell the house and everything in it. All I saved were the important small cherished items I had brought from Colorado and a few new keepsakes that had been added to the pile from the kids and Bob. So, as before, we packed our clothing and took the boxes of cherished mementos and things we just couldn't part with over to my parents', who agreed to store them and the cars while we were gone.

About a week before we left, Bob got some kind of flu bug or something that kept his mind confused, and he kept forgetting things, like where he had put his keys and why he had gone into a room, you know, that sort of thing. It happens to all of us, but Bob seemed grumpy and out of sorts about it. I didn't understand why at the time, just thinking he was coming down with the flu and that he needed extra rest because the stress of moving was wearing on him a bit.

I tried to ease the burden of moving by handling the majority of paperwork and daily tasks. Bob was still working his security job and helping his uncle up to the week before we left. I had finished my time with Tony Robbins and had gone through the house cleaning and showing possible buyers the place. It was an easy sell; the place was on a beautiful hill overlooking the ocean in La Jolla, the perfect spot for anyone looking to move into the area. Within a few weeks, the place was sold, and the buyers were given the keys two days before we left. Everything had fallen into place, and we had decided to stay with my parents before we left since my dad had offered to take us to the airport. We had a big going-away party, and our family came to see us off. It was bittersweet for us. I would miss my family and the kids, but it was going to be a great adventure for Bob and me.

"Sheri, can we look at these schedules today?"

I snapped myself back to reality with a start. I looked around my tiny office, confused for a moment. My dad was standing in the door looking at me.

"You okay there, honey?" he asked, looking concerned, a stack of papers in his hand.

"I'm fine." I smiled brightly.

He walked in and sat in the chair opposite me. "Didn't look so fine to me. Something on your mind you'd like to talk about?"

I sighed and smiled. "No, Dad, I'm fine. I've just been thinking about the past a lot lately. I lie awake at night and remember what my life was like and how Bob and I met. Things like that have been coming to me a lot in the last few days. I'm not sure why, just feeling nostalgic, I guess. I was just sitting here now, lost in thought, remembering the move to Italy."

"Oh, yeah, that was a fun time," said my dad, shaking his head sarcastically. "Just when all this started with Bob."

"Yeah, but we didn't know at the time," I said, leaning back in my chair. "I just thought he had the flu. I didn't really understand it until I saw that job application he was trying to fill out when we got back two years later, and it was all garbled. I had no idea this had been going on the whole time we were in Italy. He kept a lot of it from me, only sharing what he had to. I guess he must have been pretty scared."

"I imagine I would be too if it had happened to me," answered my father, looking out the window, wiping at the corners of his eyes. "I'm just so grateful it hasn't happened."

I looked tenderly at my father. He had been going through his own set of health problems lately with his heart. Mom and I had been worried that he was sick and had lost the will to live, but with all that had happened with Bob's decline, my father seemed to rally, often helping in the daily care and maintenance of Bob. Then he began helping me when I decided to start the caregiver business all while watching my husband's steady decline with a tender and sympathetic eye. My mother often said to me that because of what had happened to Bob, my father had felt the need to be of use and that perhaps it had even prolonged his life by a few years just because he was helping someone else who needed

more help than he did. I guess that's true for all of us; we just need a sense of purpose to keep us going.

"How's your heart doing, Dad?" I asked softly.

He cracked a smile. "Old tickers still chugging along. You look tired, though."

"I feel tired," I said, suddenly feeling the weight of the world on my shoulders. "This hasn't been an easy journey, and I see Bob getting worse by the day. There's not much else that can be done for him medically, and I hate seeing that vacant stare of his. He would have hated this had he known. He was such a virulent man so full of life and charisma. People loved to be near him; to hear him laugh and tell stories were such a treat. Now he just stares silently, almost no recognition on his face of anyone or anything."

My father looked down and wiped his glasses with a tissue, clearing his throat and fighting back tears. "It's been rough on all of us watching him decline. Makes you start thinking about your own mortality, but I guess things happen for a reason, and we've all become better caring human beings because of this."

I looked up, remembering my father had some papers to give me. "You wanted to see me about something?"

"Oh, never mind. Let's go home, it's late. These will keep another day." I agreed and headed home, the events of my life in Italy still fresh in my mind.

I drove home spinning thoughts through my head of how we had lived in those days with Bob's disease taking silent hold of him without us ever knowing what we were up against. Even now looking back, it's hard to say which exact moment it was that I realized something was wrong. I thought back again to that month in San Francisco. Things hadn't turned out exactly how we had planned, and when Bob left for Italy, I was stuck behind in San Francisco for another month trying to get my visa sorted through. I spent

days at the embassy filling out forms and pleading my case with officials who were less than thrilled to put a rush on my visa due to my husband's job. So finally, I managed to clear the visa process and was allowed to join Bob, who by this time had gotten us pretty well settled in.

Upon my arrival, I couldn't help but notice a change in Bob. We'd been apart a month, and one doesn't notice slight changes in one's spouse in the day-to-day activities, but over a prolonged time frame, they can seem huge. I found that Bob was a little more agitated and distracted at times. While it may have been easy for him to explain it all away as a bad day or lack of sleep or the continental time change, I slowly began to mark the changes, and concern for his health began to nag me on a daily basis. He was suddenly forgetful of directions to and from the city, frequently getting us lost in the countryside and surrounding areas. When I would ask him, he would get flustered, often covering his confusion by saying he wanted to explore the country more and decided to surprise me. He would shake his head and say, "Let's just see where we end up." Other times, he would just take off for work and not come home until late with no recollection of where he had been. As usual, Bob would just throw himself into his work more and ignore the signs I was pointing out to him. I asked him repeatedly to see a doctor about his health. I was convinced he had some sort of heart problem that was making him so tired that he was acting in this strange manner, but he would just shrug it off and kiss me until I forgot all my worries and convinced myself I was wrong.

Months went by this way, and it became a part of the daily routine. I'd run behind Bob looking for his car keys and finding things in unusual places as he yelled at me from the kitchen to find his shoes and other various items he couldn't find for the day. Like a good wife, I'd try to do little things to

brighten Bob's day, making him gourmet dinners and finding the healthiest and freshest ingredients for his meals, thinking that if I could improve his nutrition levels, he might kick this whatever it was. But nothing helped, and finally, our time in Italy came to a close, and we had to make the decision about what came next for us. I could tell Bob was having trouble at work the last few weeks, but it was something he didn't want to share with me, and I never pried; I felt he would tell me when he was ready.

We made the decision to go home to San Diego, and my parents were thrilled to have us back, but like me, they noticed the change in Bob. I finally convinced Bob to go see a doctor about his health, and he reluctantly went. I figured by this time, he was scared about what was happening to him as well as me, but he was afraid of the answer he might get. I went with him, and the doctor confirmed what I had begun to suspect—there was a problem, and it wouldn't be getting any better. Bob had Alzheimer's, and he would continue this decline until one day his body would forget everything it knew and be unable to sustain the necessary bodily functions to keep him alive. The news shook us like an earthquake. Our whole world was about to come apart, and all I could do was watch it happen.

I pulled into my driveway and got out of the car, my angel caregiver coming out to greet me. Greg took my hand, his face grim, and led me to a patio chair. Taking a deep breath, he slowly squeezed my hand. "Sheri, I think it's time we talked about Bob. I don't think it will be long now. He's struggling with little things. Breathing is most important right now, and I think we need to face facts."

I struggled to hold back my tears knowing this was coming. I swallowed the lump that had come up in my throat. "I knew this was coming, I saw it over the last few nights. I didn't want to admit it to myself."

"You want me to handle the DNR? I'll be here to the very end if you like." He looked sympathetically into my eyes, and I knew it was time to get everything in order. This time he wouldn't rally, but I always hoped that God would take him in his time and not on the doctor's orders. This was my firm belief and had been the idea that had guided all the actions I had taken in Bob's defense against those who had fought me to just let him go. "I have to think about some things, Greg. I've had funeral arrangements set for a few months now, and all the paperwork is in order for end of life procedures. I'm just not sure that I'm ready to say good-bye. I thought I was, but now that it's staring me in the face, I just can't."

"I understand," he said gently. "Remember there's nothing that can be done. You don't have to make any more decisions. He's doing what comes naturally. I'm not asking you to pull the plug on him. I'm just telling you it will be soon. I think you might want to call your family and let them say good-bye." He stood and started to walk away and then turned back to me. "Sheri, I think maybe he's waiting for you to tell him it's okay to go. He still wants to take care of you on some level, and I think he's afraid to leave you this way. As I said, I'll support you in this all the way. I'll see you in the morning."

I sat there, letting it all sink in. So here it was, the moment I had been dreading for all these years. I couldn't deny what Greg had said. After all, I had told countless clients the very same thing since starting my journey with Bobby's Way. How many families had I helped over the years? Dealing with loss and family grief was my business, and now it was also happening in my own life. I quietly slipped into my flat, not wanting to face my parents right now with all the things my heart was struggling with. I laid my things on the table and slipped into the hospital bed without turning on

the lights. I could hear Bob's labored breathing as I lay beside him, stroking his cheek and head. I couldn't eat or sleep now; all I wanted was to be here with him right now, holding him and helping him ease his mind that I would be okay.

I lay there through the night, listening and praying. Once again, I thought back to that first morning when Bob's illness had progressed to the next level. It had been getting worse once we returned home so much so that we could no longer be intimate, something we had never gone a day without. We had always taken great comfort in each other's arms, always sleeping skin to skin without a second thought, but at a certain point, Bob had reverted to a childlike state, and it was no longer a possibility for us. The memories of that day flooded back to me through a torrent of emotions as I lay there holding my beloved in my arms.

Chapter Eleven

I opened my eyes, yawned, and stretched. It was Monday, about 6:00 a.m., but the alarm had not gone off yet. I always seemed to wake up before the six-thirty alarm. I was so determined the night before I set it thinking I might be able to just sleep in a little, even if it was only another half hour without worry. I slowly stretched and looked over to see Bob lying on the bed sound asleep. I sighed, looking at his angelic face sleeping like a little child, his head on the pillow, looking peaceful and serene. To look at him now, you would never know he was up pretty much all night last night.

I had been so tired and overworked from the day's events all I wanted to do was crawl into bed with my Bob, but when I got home, things had changed. He was different now than he had been when I left for work. He was still that sweet smiling person, but he had lost that hard man edge and seemed to be more childlike. I hadn't paid it much attention at dinner but had instead helped him eat his food as usual, cutting up his food so that he could just pick it up in case he had trouble with the fork. But when it came time to get him into the shower to clean up, he became agitated looking around at everything with confusion, not knowing what went where or why the water was dripping from the head of the faucet. He kept pointing and asking why, and I tried to explain as best I could. I stripped down and got in

with him like I had always done in our marriage, but tonight when I stepped in, he turned and took the washcloth from my hand and tried to cover me up.

I had told him, "No, Bob, it's okay. This is normal. Remember we get naked to wash in the shower," trying to reassure him that everything was fine.

He lowered his head, mumbling, "No, it's not right… just doesn't feel right." Then he trailed off into more confused mumbling, still trying to cover my body while I fought with him over the washcloth.

I finally gave up and let him do it so I could wash him and get him into bed without any more confusion. I was so tired I just didn't feel like fighting tonight. I finally got him clean and dried and into a clean set of pajamas. He sat on the bed looking out the window until I quickly finished my own shower and got him tucked into bed. I then lay down next to him, almost falling asleep when I felt movement. I opened my eyes to see him pressing the edges of the blanket around me, trying to cover me up again. I smiled at him, and he backed away, softly muttering to himself and looking so uncomfortable. He kept looking at me in bed and shrinking away and shaking his head, saying, "No, no, no."

I finally got up out of bed, and he settled down right away and quickly drifted off to sleep. *Well, I guess I'll be sleeping on the couch tonight*, I thought, grabbing an extra blanket and my pillow from the bed. I had just settled down to sleep when I heard a commotion from the bed. Bob was trying to push back the covers and get out, and I asked him what he needed, but he didn't pay me any attention. He was sleepwalking, he walked around the bed and opened the front door.

I quickly got up and followed to make sure he was all right. He stepped onto the balcony and began peeing freely into the bushes, big smile on his face. He had forgotten where

the bathroom was and believed the front door to be our tiny bathroom door. I hated to wake him up. I just knew if I did, it would scare him so badly, not knowing where he was.

I had learned my lesson the hard way a few months back when I had tried to wake him for his shower, and he had been so scared, wide-eyed, and frightened like a child. He had grabbed me by my arm and shoulder, sinking his fingers in hard. I had been covered with bruises by the time I had settled him down.

This time, I patiently waited next to him while he finished and found his way back to bed and snuggled down beneath the covers again. Well, that will teach me from now on, I would have to be ready for these nightly excursions. I'll start keeping a flat Tupperware container by the bed. That way I can catch it midstream if I have to.

My mom got worried when she saw the deep purple bruises on my arms and neck. I told her what had happened and warned her that when he was scared, he would grab you by whatever he could get, including your neck if it was within reach. I knew he would never seriously hurt me, but we had developed a system for dealing with these scared tense moments when he would have you by his iron grip. I had filled a spray bottle with water and carried it around with me like we used to do with the cats. When Bob had me sometimes so hard by the throat that I couldn't breathe and then one squirt in the face with water, he never knew what happened. In fact, Bob would release me and look at me so surprised.

During these moments, I'd make a game out of it, keeping it light because he really didn't know what he was doing. I'd say, "Wow," with my eyes wide open with a shocked look on my face. "What just happened?"

He'd smile, snap back from wherever he was, pat me on the head as if to say, "Don't worry so much," and then go on his way.

I rolled back over, not wanting to drag myself out of bed and the comfort it afforded, but I had work, and the caregiver would be here soon. *So get up, come on, Sheri,* I thought to myself. I finally stumbled to my feet, groggy and tired from the lack of sleep. I went to the bathroom and started my morning toiletries and then heard Bob stirring in the next room. *Well, let's try to get Bob to brush his teeth,* I thought.

Bob heard my electric toothbrush and came in to watch. He'd been fascinated by my power toothbrush lately, and he'd stand watching it and trying to touch it while it's in my mouth. It kept him entertained long enough to get my teeth brushed, and I would hand him his own toothbrush, and he would look at it for a minute then want to eat the toothpaste. Just like a small child, I had to take the toothbrush while he was holding it and "help" him brush his own teeth while I kept him from eating too much toothpaste. Finally, his teeth were brushed, and I didn't even want to try to get him in the shower again. After last night's ordeal, I decided to switch shower time to the evenings. I took him back to the little bedroom and asked him if he wanted to get his clothes on by himself or if he wanted my help.

"No." He shook his head and smiled at me. "I can do it."

"Okay, I'm gonna shower then, but I'll be right here if you need me, Bob."

He nodded and went about the room opening drawers. I watched him as he began to pull out his clothes. He was looking good, everything fine. Quickly, I took advantage of this moment and raced into the shower, finishing as fast as I could before running back in to take him to the house for breakfast. I dried off and threw my clothes on, not really paying much attention to what I had selected. These days I was lucky to have two matching socks, let alone a whole coordinating outfit. Bob had been the Armani man. He was always very meticulous about his appearance, only the best

Armani suits and carefully selected ties, but being the VP of Global Operations at Hewlett-Packard, he was expected to look good.

I walked back into the bedroom to see Bob standing now in front of me, big smile on his face, with what he had selected to wear that day. I looked at my beautiful man and stiffled a laugh. He'd got not two but three baseball caps on Miami University, Key West, and another that says Harley Davidson all facing in different directions. His pants were on his arms where his shirt should be. Bob had somehow got them on as a sort of shrug around his shoulders but no shirt beneath it. He had another pair of pants on his legs—yay, at least, he got those right—and his shoes on the wrong feet so that the toes were facing out in the wrong direction.

I smiled warmly to match his proud face. "Wow, is that the look you want today?" I asked him, hoping he'd change his mind.

He beamed brightly. "Yes, of course."

"Okay," I said and smiled brightly back at him. "Well done, honey, you look good, but can we try something different with the shoes?" I never told him he was wrong. Why bother telling him? He just didn't understand.

"No." He frowned and looked disappointed. He reached over and picked up his briefcase and said, "I've got to go to the airport. Got to go to work."

I looked shocked; he hadn't been to work in months since the onset of the dementia. "Oh, you do?" I asked.

"Yes, yes, got to run, plane's leaving," he said, a little agitated but with a smile. He kissed my cheek, and off he went back onto the little dirt road behind our property, not walking but slow jogging.

Confused, I started after him, but my angel caregiver, Greg, had just pulled up and jumped out of the car, shouting, "I've got him, Miss Sheri, don't worry!" With my angel

caregiver right behind him, Bob jogged around the house and yard. I walked back inside the house, shaking my head. Now that Greg was here, I could take the time I needed to get myself ready for the day and to work without having to worry about Bob. I grabbed my little Bible and went into the kitchen across the walkway of our granny flat, poured myself a cup of coffee, and sat out on the patio to do my daily devotions that would keep me centered the rest of the day. I loved Bob and our crazy life, but I had learned that with the onset of his disease, I had to take time for me, or I would get to the point that I was so wound up that I couldn't deal with him in the right frame of mind with patience and love. Instead, I was harsh and exasperated with him, and he could feel my mood and most often would shrink away, not wanting to be near me.

I couldn't really blame him. He was a child again; in his mind, he didn't understand why people would get so mad at him for things he did, like the time we had gone out to the Viejas Indian Casino. Bob and I were regulars out there every Saturday night. They would have dancing in their club with a rocking DJ, and Bob loved to salsa. We would go out and have dinner at the grove because I hated buffets and then go into the club. We got to be so popular with the people that worked there that Bob knew all the security guards by name, and they would always come up and chat with us whenever we were there. I had tried to keep our lives as normal as possible when we had first learned about his having Alzheimer's, so we still went to the club and had our normal Saturday fun until the night I lost him. I had left Bob on the dancefloor to use the restroom, asking one of our security friends to keep an eye on him while I was gone for a minute. There had been an altercation with a man that had too much to drink, and the security guard had gone over to attend it.

When I got back, Bob was nowhere to be found, and Miguel, the security guard, felt so bad that he enlisted a few of the casino floor managers to help find him since they all knew him. We combed the club and part of the casino floor before we heard screaming and shouting coming from the ladies' restroom. Instantly, the hair stood up on the back my neck, and I got goosebumps. I knew it was Bob, and I imagined in that instant that he'd fallen and cracked his head open. We rushed to the sound of the commotion to see Bob standing next to the sink calling out my name. He had gotten scared being alone and came looking for me in the ladies' room. One of the female casino managers had found him and told him he couldn't be in there. While a few lady patrons were shouting and screaming at him to get out, one sweet little old lady had even hit him with her handbag.

I ran up to the door and called his name. Bob smiled and came over to me like nothing was wrong. "There you are," he said calmly with a smile. "I was looking for you."

I hugged him and kissed him, so relieved to have found him. "Oh, Bob, I was so scared I thought I had lost you," I said with tears in my eyes.

"I'm fine," he said with a frown. "But, Sheri, why were those women screaming? What's wrong with them?"

That was when I had realized our normal life was about to change again. He really didn't understand what he had done wrong. His mind was changing, and things that used to be common sense were now new concepts for him. I understood now that I couldn't take him out anymore, and the sweet casino staff had by this time gotten very tired of the constant outbursts from Bob and had asked me not to bring him back.

I sighed and sipped my coffee and prayed for the day and strength to deal with the challenges I would be faced with. I then asked God to give me the verse that I would need

to carry me through the day. I opened my eyes and took out my little Bible, opening it at random, or so I thought, but every morning without fail, I would pray, and God would always guide my hands to the right page, and it would always be exactly what I needed to hear that day to encourage me. Today was no different; there on the page in front of me were the words, "Do not worry. Be of good cheer, for the Lord is with you." That was all I needed to know before I burst into tears. He was with me! I was not alone, and he was always so skillfully guiding my life in the direction it was to take.

I finished off the rest of the page and felt all my tension and stress melt away. Now I was ready for the day. I finished my coffee and checked in with my mother, who was just getting her breakfast in the kitchen. My dad had already gone. I was going back to the nursing home today where I had gotten a few leads on some coworkers of Greg's. I was going to steal a few really good workers that cared about their charges as if they were their own family. I wanted to revolutionize home care and give our loved ones a better quality of life rather than be shipped off to a home where they would be neglected and undercared for until they were so depressed that they gave up hope and passed away with no more will to continue. We treat our prisoners in the USA better than the elderly in this country, and that's just not right in my book. Something needs to be done, and I guess I'm the woman to do it.

I got into my car with my contracts and paperwork in the hopes that I would be able to sign up the two girls on the spot to start work this week. I had two potential clients I was looking at, and I would need caregivers. One was an elderly gentleman who needed someone during the day to help cook meals and shower duty so that he didn't slip and fall. The other was a woman with cancer who had been sent home on hospice care. The family needed someone to come in and sit up nights while they slept. *So not a bad start, Sheri. Things*

are going to be great. I checked my mirror and gave myself an approving nod before heading down the street past the drugstore and gym where Bob and I had our membership. I pulled in and parked to run inside the gym really fast. I asked for the manager at the front desk. A medium-built girl with pink and blue hair and wearing a bright yellow spandex suit with black trim greeted me with a smile as she called him on the intercom.

"How's Bob today?" she asked.

I smiled warmly. "He's doing good today."

"Should we be expecting him in later?" She smiled.

"No, not today or ever again." I chuckled. "That's what I came to tell your manager. The neighbors have been so sweet. Everyone's pitched in and donated about a hundred yards of chain link fencing to put around the property to keep Bob in. So no more escapes in the middle of the day to come down here to the gym."

"That's wonderful," she exclaimed. "I've often worried about him finding his way home again."

"You and me both," I said, shaking my head. "That really surprised me last May when I found out he was leaving the house and coming down here. It really scared my parents too. They had been watching him during the day and suddenly discovered he was missing. Then a few hours later, he turned up again. Same thing started to happen every day, so one day, I followed him. Boy, am I glad your manager was so understanding and let him come work out when he wanted to. But now he's got a regular caregiver because it's just too much for my parents to handle."

James, the manager, walked up and smiled, shaking my hand. "Sheri what can I do for you? Everything okay with Bob? He's not missing, is he?" Concern was written on his face.

"No, thank God." I smiled and shook my head. "Just telling your desk clerk here that you guys shouldn't be seeing

Bob anymore. We had a chain link donation from our neighbors, and so it's being installed today. Now we can lock the gates, and Bob won't be able to get out."

"Ah, that's great and sad at the same time. I'm gonna miss him around here."

I laughed and smiled at him. "Well, you've been just great through this whole thing, letting him come in and work out, even though we haven't had a membership in a year."

"Well, it's not a problem. He's just a nice guy that likes to work out. I had an uncle that had dementia, so I know what it's like to watch them go through it. If working out makes him happy, why not let him? He's no trouble, and he's not bothering anyone. We just worried about his safety getting home."

"Well, that's why the fence is so important. I didn't care if he came down as long as he was safe, but I watched him come home the other day, and I was shocked. Crossing traffic is very tricky for him, and he almost got hit twice. I can't let that go on anymore."

"No, I understand. At least, you got some help, though. That's nice of your neighbors to pitch in like that."

"Oh, I know it's a complete godsend. I've finally realized that I can't do this on my own, and even if I could, I'd be robbing people of their God-given right and desire to minister to someone in need. Who am I to cause that kind of disruption in God's plans for us all?"

He smiled and nodded in approval. "It's important to let others help you when you need it. Otherwise, it'll make you crazy never having a peaceful moment to yourself. If others are volunteering, why not let them? It gives you time to get yourself together and organized."

"That's very true. I had to learn that lesson when I worked for Tony Robbins. Walking the ring of fire twice really taught me how to let go of your mental inhibitions

and just accept what is and roll with it. If you let it, your mind can overcome any physical objection the body can throw at you."

He stood looking at me, leaning over the counter. "That's definitely true. The mind is stronger than the body. I've watched an eighty-year-old grandmother lift a car off a kid trapped underneath it simply because the child was in danger, and she said she needed to do it."

"Yeah, the mind is a powerful tool," I said, pulling out a stack of cards from my purse. "James, would you mind if I left you some of my cards? I recently bought my own franchise company, Bobby's Way, and I'm trying to help other families like myself that have loved ones who need a little extra TLC without being placed in a home. My goal is to keep people with challenges in their own homes in familair surroundings with family members by their side for as long as possible. I've put Bob in those nursing facilities for weeks at a time when I was new to this disease, and I've seen firsthand what they do, and I'm not happy with it, so I'm offering my services and angel caregivers to those who feel as I do. So if you have members here—I know you do a lot of physical therapy and rehabilitation—who are in the market for what I can provide, please pass along my card."

He looked down at the small stack of cards in his hands. "Absolutely, Sheri, I would love to help out both my elderly clients and you. I think what you're doing is great. I see a lot of elderly come through those doors needing rehab because they have fallen and broken a hip or leg. Most of their families want to pack them off to a nursing home because they happen to be a little unsteady. I hate to see that happen, especially when there's nothing wrong with them mentally or physically that a little extra caution can't fix."

"Exactly," I said with a smile. "I gotta get going, but thank you, James, for all your patience and understanding

with Bob. I really appreciated it. Hopefully, you won't see him turn up here anymore."

"No problem, Sheri. He's always welcome, and if he does happen to show up, I'll call you."

"Thanks," I said, smiling and running out the door back to my car. It had always amazed me how, with all the confusion going on in Bob's head, he still managed to make it down four city blocks to the gym and home again without losing his way. I guess it just goes to show that deep down inside, there was still some signs of the old Bob. He was still in there, and what was really important to him throughout his whole life, his personal appearance and physique, was in his mind still important to him now.

I drove to the hospice center to check on those two ladies that Greg had directed me to. They both got off in fifteen minutes, and he had called ahead to make sure they would be willing to meet with me. Thankfully, they had said yes, and I was prepared to give my best speech ever. I had been thinking so much lately about my life and Bob's condition. I had come to realize that through it all, I had been so focused on what my issues were and what my problems had been that I couldn't see the big picture yet. I had been going around with my spiritual blinders on, refusing to see the beauty and humanity in others.

It's amazing how people will rally round you to help, just like our neighbors with the fencing. I found it so hard to ask for help. I was used to being in charge and taking everything upon my shoulders, which I found interesting, me wanting to maintain control of everything just so that I wouldn't have to bother anyone or put anyone out by asking for that help that I so desperately needed. What I found is that it robbed so many people of the opportunity to truly step up and do some beautifully spirited things in Bob's and my life. Once I lifted that gate and allowed the help to come,

my life changed. I could take a breath and take a step back to allow myself the time I needed to regenerate my energy, and I found such beauty in people that I thought would never have existed otherwise.

Warning, though, I learned early on that I had to stay away from the "energy vampires" that rob you of your power. They take your situation on with such drama, tears, and worry that you're completely drained by the end of the conversation. I still believe, though, everyone has a good heart. Everyone wants to help do something, even if it's only a little thing. It can mean the world just to be given that few moments of peace and contentment we all so lack in our lives when we try to keep control. However, I came to understand that stepping into that world is just not for everyone. You just can't ask someone to be more than they are capable of being right at that moment, and that's okay. Everyone comes to their own awareness of things at different times, and those who were not ready to be involved when it was someone else's issue are usually the first to jump to the aide of another whom they are closer with. I've witnessed these little aha moments in others who once didn't understand why I did what I did suddenly change and say, "Wait, I get it now. I see what you went through, and I understand you made the right choice."

Lying there in that bed thinking about all these things made me grateful that I had so much time with Bob. I hadn't chosen the easy way out, I tried to, I really did, but seeing him in those homes so drugged out of his mind when I would visit and him not knowing me and his children just made my blood boil. How could I look him in the eyes and stand knowing that he was being robbed of his last precious days when he really should be home with me and those who loved him, happy and safe? No that was never a choice I had been comfortable making, and I pulled him out as soon as I could to have him stay at home. I had sacrificed so much to live up

to my marriage vows, 'til death do us part, even including buying a home care franchise so that I could get paid to have my husband stay with me. All of this, my new life and career, had been made all to keep my Bob safe and secure with the best care I could possibly give him. And as it turned out, God knew what he was doing because the path I had chosen to help my husband allowed me to help others like me, and as it turned out, I loved every minute of it. This had been my true calling all along, and as Bob's health had declined and he finally became bedridden, I had grown to understand that God had helped me through Bob to find what I had been searching for all of my adult life—a true purpose and a reason to get out of bed in the morning. Bob's steady decline had been hard to take, but my strength had been truly tested when his mind no longer allowed for the use of his legs. The physical therapists had stopped coming, telling me there was nothing to be done now. It was the same with eating; he'd started choking on most everything and lost so much weight from 150 pounds down to about 95 pounds, and on top of all that, he had massive seizures. But it was all part of the deal I had signed up for. It wasn't up to me. God had a plan for me and Bob, and this was all part of our movie after all. Whether Bob stayed or went was all up to God. All I could do was support him and care for him as he would have done for me if our places had been reversed. I couldn't let him go without doing everything I could to ensure his comfort.

Chapter Twelve

The faint streaks of early morning light were beginning to filter through the gauzy curtains to my right. Bob's bed was right near the window so good that he got some great sunshine and a nice little breeze on a summer day. The birds began to chirp; I just loved that he got to hear the little birds he loved so much every morning. I hadn't slept all night just thinking about my next course of action. I moved slowly so as not to disturb him. Bob was lying perfectly still in the hospital bed, sleeping so peacefully, the feeding tube pumping slowly. There had been no seizures last night. *Good Bob, doing a great job, honey*, I thought to myself as I began the usual routine. I jumped in the shower, quickly listening to the monitor on the shelf next to me. I've learned to shower in five minutes flat through all this. Finishing my morning toiletry helped me ready myself for the decision I had made through the night. I walked the eight steps back to Bob's bed, and I rubbed him down with some baby wipes, getting him clean. I followed up with some nice lotion and got him into his favorite shirt; "NYPD," it says in big letters across the chest, only now it was cut up the back, so it was easier to get on him like a hospital gown.

He doesn't open his eyes anymore, just lay there breathing, but as always, after I get him ready for the day, I talk with Bob. I try and make it cheerful, even though

I'm not feeling it today. I tell him his name, my name, his children's names, Bobby and Gina, and then go into my "Happy Birthday" song. Interesting world to live in…in the moment…no past, no present, only right then and there. I kiss his cheek and turn on the music, always soundscapes, something soothing to help him through the day. I pick up the phone and slowly dial the number. One by one, I call every person who's ever had anything to do with Bob's life, the kids, his ex-wife, family members, friends, coworkers, anyone who ever meant something to him. I left messages on phones, and those I personally talked to all got the same speech.

"Hello, I'm calling to let you know that Bob isn't doing well today. His breathing is labored, and I think you should say good-bye to him now. If there's anything you have left unsaid that you feel needs to be known before he passes, now is the time to say it. He can't open his eyes and respond to you, but I know he can hear you. I'll hold the phone to his ear so that you can say good-bye."

To the children and immediate family who picked up, I told them to let Bob know that it was okay to let go if he wanted to. I felt it was important for him to know that it was okay to leave us. His journey was over, and if he chose to go, it would be to a better place where he would be out of pain. This was the hardest call I had to make. I knew it was right to give them all a chance to have closure and to tell him their good-byes in person, but for some, it was just enough to get the chance to tell him how they felt over the phone. This process was hard enough knowing the eventual outcome, but I wanted everyone to have that chance to say one last farewell so that no one would be left with any regrets. And selfishly, I had hoped that with all the support of his family and those he loved so dearly telling him it was all right to leave us, he might take a little comfort and strength to make

the transition on his own, and I would be spared the pain of telling him myself.

When the last person was called and all the good-byes were said, I excused myself to go into the house. It had been a rough morning, and I needed a little release from the tension and stress I was suddenly feeling. I poured myself a little coffee, but my heart just wasn't in it. I tried to sip, but it stuck in my throat like sandpaper. I choked and gasped for air, finally dumping the contents of the cup down the drain. My mom came in and saw me standing at the sink looking off into space.

"Rough night?" she asked, rubbing my back gently.

I started and weakly answered, "Yes, didn't sleep much. Bob's breathing is becoming more labored, and I'm not really sure what comes next."

"It's not in your hands anymore, so we'll just have to wait and see." She reassured me as she walked out onto the deck. "Don't forget your nephew is coming in the morning."

"Oh, that's right," I said weakly. "Who's picking him up, Dad?"

"Yes," she said, plumping up a few pillows on the patio couch. "Are you going to work today?"

"Yes, I'll be leaving soon," I said, grabbing my purse and hunting for my car keys.

"Honey, try not to worry, okay?" she said, walking back into the kitchen.

"I gotta go, Mom," I said, trying not to fall apart. I found my keys and ran out the door. Greg pulled up into the drive and got out while I flew down the stairs, desperately clutching at my sanity.

"Hi, Miss Sheri, I got him. Have a good day at work." He waved as I silently jumped into the car. If anyone got what I was going through, it was him. I never had to tell Greg what I needed; he always seemed to know almost before I did

sometimes. This week was tough, and I was looking forward to my nephew's visit this weekend, but now with how Bob was responding, I wasn't so sure it was a good idea after all. What if he passed while my nephew was in the house? Poor kid had been through enough trauma last year when his father died, and now to have his uncle pass right under his nose might be more than he could take. I sleepwalked through the day, not really paying much attention to what was going on around me. It all felt like a dream, and I was numb to it. I smiled and laughed and carried on like nothing was at all wrong, but inside I felt dead. I somehow made it through the day and dragged my tired body home.

While parking my car, I suddenly felt very old. I needed that mug of tequila very badly tonight. I climbed the stairs, my feet heavy as lead, and dropped my purse into the deck chair. I opened the kitchen door and got my giant mug out of the cupboard. I paused in front of the fridge before I filled my mug with ice and tequila. The dogs came running, and I walked outside and flopped down in a chair, the dogs, Moochie and Alfie, dancing around my feet.

"Not tonight, fellas," I said weakly, rubbing Alfie's head. "No walk tonight, I'm Just beat." I sat there for an hour until Greg came out on his way home with the baby monitor in hand.

"Hi, Sheri, I'm on my way out."

"How's it looking tonight?" I asked, hopeful.

He rubbed his head and said, "Honestly, not good. Could be any day now. I think you should be ready."

"I've been ready for a year. When the doctors said he wouldn't live longer than a few weeks, I was ready. When they claimed the feeding tube wouldn't keep him alive more than a month, I was ready. He's outlasted them all, and every day he lives is a miracle. So whenever he decides he's ready, that'll be the day."

"But have you told him, Sheri? Does he know that you'll be okay without him?"

I shook my head slightly. "Then I think you should tell him. It might be all he's waiting for. He needs to know that you'll be taken care of. He's always worried about you so much. If you're his unfinished business, then he won't go." He gently laid his hand on my arm. "Well, you just think about it. I'll see you in the morning."

I knew he was right, but I just couldn't bring myself to say it. I was too scared to say good-bye to my Bobby. I secretly knew in my heart that it was exactly what Greg had said, that Bob was waiting to hear it from me. He needed me to say it was okay to go because the truth is I would be fine without him. I would miss him, of course, but he would be out of pain and suffering, and isn't that what I really wanted anyway? How do you tell someone you've been with so long that it's okay to leave? I stayed outside most of the evening thinking things through. I just couldn't bring myself to go in and face him with all those machines hooked into him.

When I did finally go in, I just sat by his bed and stroked his face and head, staring at him there, watching those machines keeping him alive. He was more machine than man now, everything being controlled by the perfect timing of each machine synced to the next. The gentle swooshing of the air hoses and the constant drip of the IV fluids, all sounds I had become accustomed to in the last year. All these things were now running his body and forcing it to stay alive. I stared all night long, never sleeping, just being with him, seeing him as if for the first time, and what his life had become just one constant symphony of machine noises and beeps. Bob would have hated this—to be bedridden for so long, not able to dance and paly his music.

The first streaks of dawn broke through the curtains, and I finally had the courage to say everything I had

wanted to say. All the years of our marriage summed up in a few short lines, they didn't seem adequate, but it was all I had. I reminded him of all the good times we had and some of the not so great times. I thanked him for being the amazing husband he had always been to me, for loving me unconditionally when I knew I had made it difficult, and lastly for allowing me to share in the raising of his two beautiful children whom I had come to love as my own. I was grateful for the little gifts he had given me, the joys that I would always treasure and take with me in my heart no matter where I would go, and finally, I said the one thing I had denied him up to now—I told him that I would miss him but that I would be fine when he chose to leave. I left it up to him when and where he chose to go.

When my heart was emptied, I stood up and sighed. "Bob, it's morning, and my nephew will be here soon. I'm gonna go grab a quick shower, and I'll be right back. If you choose to go, it's okay. I love you, honey." I leaned over and kissed his lips and then went into the bathroom.

I was exhausted and felt so emptied inside. I stood under the water for a few minutes, soaking up its warmth and letting my mind go, trying not to think of anything but how good that warm water felt on my skin. Then it was as if I felt Bob's arms around me and a gentle kiss on my neck, just the way Bob used to do when we'd shower together. I smiled, thinking about this happy memory and turned the water off. I got out and dried off, thinking very strongly about my husband lying in the next room. I walked back out to look at him and noticed something was different. I quickly pulled on my robe and leaned over him. He wasn't breathing, and his heart was still. My sweet man had passed while I was in the shower. I checked and rechecked several times almost in disbelief. I had expected it, I had planned for it, but now it had happened, and I was frantic. I cried, I screamed, I beat

on his chest, and then thinking better of it, I stopped, leaning down to kiss and say good-bye to my lovely husband.

Greg showed up soon after, and about an hour later, they came and took his body away. It had all been planned from the moment he got sick, and now Greg had come and handled it all so beautifully, so all I had to do was play the grieving widow, which was all I could muster at the time. I was just like all my clients, now helpless to my own grief and despair. I wasn't strong right now; I was torn between joy at his release and sorrow at knowing I would never wake up and see him lying next to me again. I stumbled outside, tears blinding me just as my father pulled up with my nephew. One look at my face and Dad knew. He went up to tell my mother that her grandson was here, while I sat down on the chair, numbed. My nephew, who had just been through all this with my brother's death, calmly sat down beside me, tearfully telling me it was all right to be upset. He was only ten and so strong right now I couldn't believe it. He was my little rock, and I leaned on him, telling him that his uncle was gone and that we were going to have to get along without him. My nephew just held my hand and said the most grown-up thing he could muster.

"It's okay, Aunty Sheri. He's in heaven with my dad, and he'll watch out for Uncle Bob. They won't be sad because they have each other, and you still have me."

I hugged that little boy tightly because here he was ten years old, and instead of being the one in need of consoling after his favorite uncle's death, he was being the grownup for me and offering words of wisdom that no other boy his age could have done. I sat there briefly with him, not wanting to wallow in my grief. Then I heard my phone ringing in the house, and I ran to answer it. It was a client, and they were having an issue with their mother, and I could hear her screaming in the background about not getting into the

shower. The frazzled woman needed help, and I had to be there to settle her down, so I gratefully grabbed my purse and ran out the door, thankful that I could get lost in my work and forget my trouble for another day. Here I was in the middle of the most devastating day of my life, and I wasn't even able to really grieve. I wasn't gonna allow myself to break down now; I had to be strong and push on. I had Bobby's Way to grow and support. It was all I had left of my Bob, and somehow I felt closer to Bob and my mission to free others from nursing homes while I kept working. I never slowed down for a minute, always going Mach Two with my hair on fire. I covered grief with a smile and laughter, forcing my emotions in check whenever they threatened to burst through. I didn't stop there but kept going day by day, week by week. All the training I had from my time with Tony Robbins came into play on a daily basis, plus I had my family and few friends to keep me busy when I wasn't working. It was finally all over, and I had my life back. What to do now was my choice, and my choice was to help others. I resumed some sense of normalcy, but it wasn't until years later that I had realized I had denied myself the greatest gift—the chance to love, laugh, and grieve for the most wonderful man I had ever met. He was my everything, my teacher, my lover, my friend, and at certain times my father figure when I got out of line. He truly was the greatest love of my life, and I'll always be grateful to him for giving of himself so freely to me. He taught me how to love again more deeply and strongly than I had ever dreamed possible.

Chapter Thirteen

Three years later, my business is still running steady. What started as a way to get money while I cared for my husband is now a full-blown company with over one hundred employees. I had become a success in this field, even helping others start their own businesses. I was traveling now and getting so many contacts for new clients that I couldn't keep up. My reputation had grown, and so had the bills. I saw this adventure coming to its close. There had been so much to deal with in the last several years after Bob, my father passed away and my mother's health declined, finally culminating in a massive stroke on my birthday. The damage was strong but could have been worse. At least, she is still living and able to get around. I still have my angel caregivers, and though the names have changed, the level of care never does, and I can still do my job while they care for her in the house. I keep looking for the next adventure in my life. I know it's coming, but I don't know what it will be. I just trust in God and do what I love most. I still think of Bob every day and remember our life fondly, but I have put up a wall, so to speak, that keeps that part of my life protected and in a special place in my heart where no one can touch it. I had never really let that part of me grieve, I guess. Oh, I was sad and unhappy, but when you grieve, there's a letting-go process that happens to you. Your memories change and take

on a glossy happy context that gives joy and comfort. Your pain lessens, and you realize that life does move forward and that new things take the place of the old. But here it was my time, and I had bottled that part of me up and shut it away.

In fact, it wasn't until years later when a young author crossed my path that I was able to finally give myself that time that I needed to grieve. Through her help in the project we took on to write this book, I was forced to recount the entire contents of my life—the good, the bad, and the amazing. She helped convince me that sharing my memories with you would perhaps help those readers who might be struggling with similar issues in your lives. So convinced that I had an important story to tell, she helped me piece the fragments of my scattered memories together in a way that would convey the thoughts and feelings that I had long been scared to explore again. I wasn't sure if I was up to the task, but Misti was confident we needed to share my experiences with you all, so here is what I learned because as they say, every story has a moral; mine is no different.

I learned that I am a lot stronger than I think I am. I have suffered under the weight of such stress and negativity that I thought I would break in two, but I survived. I have also learned that I have a great and deep abiding respect for life, not just mine but all life, and the need to maintain the quality of life for others. Life is so precious and so limited here on this earth I've learned how to make the most of each day and take what comes and roll with the punches. I've become a woman who says what she thinks and does what she wants. It's not unheard of for me to suddenly pack up and go visit a place or a person I want to see. I go after what I want because life is, after all, what you make of it. I have learned to be content and happy in my situation, whatever that may be, for the moment. I have a phrase that I use in life called LOTOS, and I live by this credo, and all my friends

hear me refer to it often to convey the feelings I have inside me. LOTOS means "life on the other side." That's exactly what this is for me. The first half of my life has passed, and a new phase is beginning, the LOTOS phase. It truly has been the other side of the coin for me. The change in me is night and day; I have dreams again for my future, something I stopped doing when Bob was sick, but now life has opened its arms to me again, and I'm really living.

I had started dancing again after Bob died. I had always loved it, and I had friends that would go with me, and we'd all dance in the round just like the old days in college. It was on one of these nights that I had met a fabulous man who intrigued me with his Latin steps. Joe was a retired dance teacher who was on a visit to San Diego to see his family. We hit it off, and it grew into a nice friendship. It's been nice to have someone to talk to again. It might grow into more, but for now, I'm happy and focused on what to do now, but whatever I do, I know that I have Bob's blessing and encouragement. It's been a great adventure, the greatest in my life, but now I can honestly say that I have gone through and come out the other side and that I'm a much stronger and kinder individual than I had been before. I am excited and happy, looking forward to the next chapter in my life. Who knows perhaps I'll sell the business and retire in Puerto Rico with my hot boyfriend.

About the Author

Misti Galves lives in San Diego, California, with her husband, Reuben Carter. She graduated from Granite Hills High School and received a BA in English Literature from San Diego Christian College, making the National Dean's List and traveling to Australia to meet with top executives in business. Her published books include *Jessica and the Missing Horses* and *Jessica and the Kentucky Hopefuls*. Misti is a member of Sigma Tau Delta, the international English honor society, and Christianwriters.com. She has won many awards for her short stories and essays. In 2011, Misti met Sheri and became a full-time caregiver for Bobby's Way, gaining firsthand knowledge and insight into the world of dementia and Alzheimer's by working closely with countless families who suffer through the challenges of daily life.

Sheri Malvestuto was born in California. In 2006, her husband, Bob, an executive with Hewlett-Packard, developed a disease that mimicked Alzheimer's, and she found herself having to quit her job to stay home and care for him. Sheri started Bobby's Way, an in-house elder care company, in 2008 where she used her resources to care not only for her husband but also countless others in similar situations. In 2011, Sheri and Misti embarked upon a joint venture. She agreed to put her life in this book in the hopes of helping others who have no one else to turn to. Once again in 2014, the two teamed up to open a senior day care center. Sheri has since retired and now lives in Puerto Rico.

CPSIA information can be obtained
at www.ICGtesting.com
Printed in the USA
FSOW01n0828310717
37055FS